ART NOUVEAU PAINTINGS

FELICITAS TOBIEN

Art Nouveau
Paintings

PADRE PUBLISHERS

Translated by Stephen Gorman

PADRE PUBLISHERS

©1990 by Berghause Verlag D-8347 Kirchdorf-Inn, Germany
English Language Rights, Padre Publishers
8195 Ronson Road, San Diego, CA 92111 U.S.A.
Fax (619) 277-5790

Printed in the U.S.A.

ISBN 1-57133-114-X

CONTENTS

INTRODUCTION

In the course of general comments on Art Nouveau little attention is paid to painting. This is rather unfair as interesting works were also created in this area. On the other hand it is understandable, considering European Art Nouveau painting found many interpreters, some famous, others less famous, but not one of them dedicated themselves exclusively to painting.

Because of this it remained a side issue, like a casual friend who no one could pass without succumbing to its charm. However, only very few painters allowed themselves to be captured by it for any length of time.

According to S. Tschudi Madson, Art Nouveau around 1900 only had a relatively short, but intensive heyday because it had "enough strength and wrath to break with the past, but not enough to build a future" (1967).

The artists seemed to have a similar attitude; they soon described it as "youthful folly".

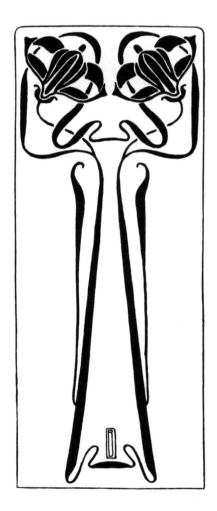

But in the meantime art historians have considered the epoch thoroughly and recognized that Art Nouveau has to be seen as an important link between two centuries. Also the fact that it was an international art movement which included arts, crafts and architecture gives it a great deal of importance.

The prerequisites for the development of Art Nouveau in the different countries were as varied as the names it was given. In Germany "Jugendstil", in England it was called "Modern Style", in Italy "Stile liberty", "Stile floreale" or "Stile Inglese", in Austria "Sezessionsstil" and in France "Art Nouveau".

As always, when art threatens to become entangled in conventional nets, new expressive possibilities are looked for to break with tradition. For those who dealt with Art Nouveau painting the problem was to turn their backs on the historicism of the 19th century and Impressionism and to use artistic fantasy again. At the same time erotic elements came to the forefront and lineation was given increasingly more attention as a conveyor of expression.

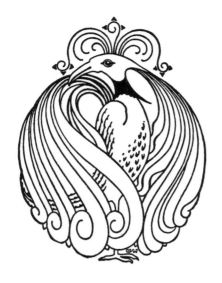

"A line is a power", Henry van de Velde stressed in 1901, "it borrows its power from the energy of the person who has drawn it . . . Every other thought apart from usefulness and purpose is dangerous . . ."

In Art Nouveau the line possessed its very own dynamism. Its task was to scintillate life and bring out emotion.

Otto Julius Bierbaum said in 1893, at a time when the new style had just begun to develop and did not even have a name, "The artistic psyche of today is complicated, contradictory to itself, divided in its innermost self. Today in art we have decadence as well as an effusive belief in the future, and the artistic yearning turns its eyes to the past as well as to the future. It is more difficult than ever before to find a certain formula for this art, but one thing is sure: we again have an art which wants to be more and is more than just an indolent beneficiary of the past. It shows itself to be a true art which is a strong, rich expression of its era, especially in its intrinsic division, in its scattering abundance of souls, in its wide range from the realistic to the fantastic, from naive to subtle. It is already obvious how it fastens on to the spiritual development of the age, how a new idealism is beginning to rise from the materialism, not uncontested by retrogressive tendencies. And so a new devout spiritual art with mystic side effects arises from the pure naturalism which, as a reaction, was necessary and healing. And this development is as rich in nuances in art as it is in life."

The Italian term "Stile floreale" is perhaps the most descriptive of all, as plants formed an important basis for the decorative ornamental creations of Art Nouveau. Flowers, fruits, grasses, twigs and leaves were used time and time again as decorative extras.

As well as this there were other leitmotifs such as the graceful virgin with noble features, soft hands, eyelids coyly sunk to the ground and flowing hair surrounding her face like a flood of waves.

Everything seems to be moving in these pictures, a never-ending river, silent but still emphatic, alluring and at the same time moving.

Sin and temptation were also used as themes in Art Nouveau painting. Admittedly it was "Sin which was first transfigured by beauty and then manifested by beauty." (Arthur Symons, 1903)

As well as the line, colour also played an important role. Through colour the artists expressed their momentary state of emotion to evoke a similar mood in the observer.

The painter and graphic artist Fritz Endell commented in 1896, "Forms and colours produce a certain emotional effect in us, without intervention, like everything else which affects our consciousness. We have to learn to be properly conscious of them. Anyone who has learned to surrender his visual impressions completely without association or secondary thoughts, anyone who has just once sensed the emotional effect of form and colour, will find a never-ending source of extraordinary and unimagined pleasure. It is actually a new world which is being formed there. And it should be an experience in every person's life, where for the first time an understanding for things is awakening . . ."

Every colour possessed a special expressive power. Red was the colour of sensuality, yellow expressed purity, blue gave out an emotional coldness and was as far removed from eroticism as green. White represented something which could no longer be touched by the senses.

The Art Nouveau painters already showed a strong tendency for abstraction as alienation was an excellent means for their ornamentation.

THE PRELUDE IN ENGLAND

Contrary to France, Art Nouveau had developed in England without a direct orientation to natural patterns. The Pre-Raphaelites had already distanced themselves from nature as an ideal.

This brotherhood of English painters was founded by Dante Gabriel Rossetti (1828-1882), William Holman Hunt (1827-1910) and John Everett Millais (1829-1896) to reform art in the spirit of Raphael's forerunners. The main aims of the group were an emotive representation of religious and literary themes and a decorative-ornamental areal division. Edward Coley Burne-Jones (1833-1898), Ford Madox Brown (1821-1893) and William Morris (1834-1896) were also closely allied to the group.

The transition from Pre-Raphaelite art to Art Nouveau was fluid, both fecundated each other as it were. The driving force was William Morris, painter, poet, craftsman, social reformer and politician all in one person. He turned decisively against the growing industrialization and especially tried to protect the arts and crafts from this. He wanted to unite artists and craftsmen in the form of the medieval guild and so produce the complete work of art.

For this purpose he formed the firm Morris, Marshall, Faulkner & Company to which painters such as Burne-Jones and Rossetti also belonged. In the company they made wall-hangings, cut glass, metalwork, furniture, embroidery, textile design and other articles for domestic use.

William Morris had a decisive influence on the English Art Nouveau movement through his reform attempts which created a close connection between crafts and painting.

However, the leading Art Nouveau painter in England was Aubrey Beardsley (1872-1898).

"The English style of Art Nouveau painting can clearly be seen in him (even if Beardsley only painted a few watercolours): working from an ideality which has nothing to do with nature, from an artistic tradition, without ever searching for contact with nature. Beardsley only continues the traditions which have a great deal of artificiality (in the sense of sensitive spirituality) as opposed to na-

ture: the Japanese woodcut (which is also behind the new movement in France), the etchers and engravers of French Rococo (which is regarded as antiquated in France but is brought to life again in the style recapitulation of historicism) and above all of Bresdin, Odilon Redon's teacher, whose fantastic etchings were admired by France's Symbolists. Beardsley can be most grateful for his chiaroscuro graphics which cover the area like frost and avoid middle tones." (Hans H. Hofstätter)

Beardsley, who was born in Brighton, was a highly talented artist who was doomed to death from the beginning. He suffered from consumption from when he was nine years old and always saw his end before him.

But instead of despairing he mobilized his last resources to use the few years still left after his apprenticeship in an architect's office and a period as an employee with a London insurance company for his artistic creations.

"I worked to please myself, and if I have given the public pleasure with this then it is all the better for me," he said in 1896. "Of course I have an aim — the grotesque. If I am not grotesque then I am nothing: Apart from the grotesque, may I say that the people especially like the decorative in my work and I lay claim to being able to control the line quite well. I try to get as much as possible out of a single curve or straight line."

The fact that Beardsley could bring English Art Nouveau to such a standard was only thanks to a lucky coincidence when he, by chance, met the publisher J.M. Dent in a bookshop in 1892. Dent was looking for an illustrator for his new edition of Thomas Malory's "Morte d'Arthur". Beardsley, who until then had only been a hobby artist, asked if he could hand in a few specimen sketches, and soon he was commissioned to prepare twenty single and double sided illustrations and approximately five hundred and fifty borders, ornamentations and margins.

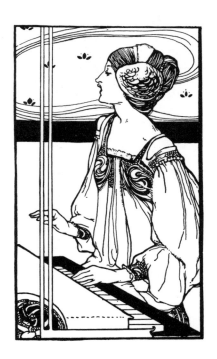

This marathon work did not just make him famous overnight, as it were, but his artistic development was completed with this task which led him to maturity at an unbelievable rate.

Two figures became leitmotifs of Art Nouveau through him — the pierrot and the femme fatale. "The pierrot is a figure of our century, the time in which we live," wrote Arthur Symons in the Ver

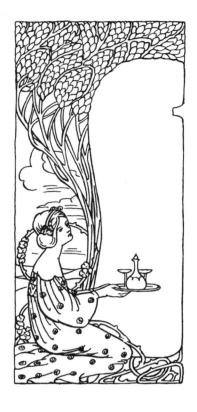

Sacrum calendar in 1903. "He is passionate, but he does not believe in great passion. Under the chalk it is difficult to see whether the grimace which distorts the corners of his mouth means he is being funny or he is laughing at the public. He knows that he has been sentenced always to stand in front of the public, that he always has to remember to be fantastic if he does not want to appear ridiculous. So he achieves perfection in the falseness, mostly frightened that a single breath of nature could displace his mask and make him defenceless . . . His world is a world of phantoms in which the wish to lead mortal feelings to perfection, a wish for infinity has crossed the border and transfixed the tender, trembling yearning feelings in a hopeless, rigid immortality."

Beardsley's pierrot had different faces. The coquettish, the reading, the dying pierrot — he illuminated him from all sides, it could almost be said that he loved him. Perhaps he identified himself with the clown as in certain pierrot representations some of Beardsley's traits can be recognized.

Art Nouveau had "as a distinct linear art its deepest and most meaningful roots in England," (D. Frey, 1942) not least through Aubrey Beardsley.

Another two artists who were important for English Art Nouveau came from the circle around William Morris. They formed an artistic unit to a certain extent as they published the journal "The Dial" together and their works appeared in this magazine. They were Charles Ricketts (1866-1931) and Charles Shannon (1865-1937).

Walter Crane (1845-1915), the teacher and patron of many Art Nouveau painters, said of the two that they were "not completely free of a touch of the unusual, foreign, even uncanny."

In various illustrations, for example "Daphne and Chloë" and "Hero and Leander", Ricketts and Shannon worked so closely together that later they were unable to distinguish themselves who had done what.

"In the pictures I attempt, consciously or unconsciously, to merge the linear drawing styles which, related to each other, are found scattered in all ages. Here, as in other places, I tried to develop something which could be imagined as a certain moment and spot in earth." Charles Ricketts commented, referring to his illustrations for

"Sphinx" from Oscar Wilde. With this statement he gave a modest insight into his art which was inspired by many different impulses. It was not uncommon for French influences to be used in England, Aubrey Beardsley had orientated himself partly to French patterns.

Other artists such as Sir William Nicholson (1872-1949), William H. Bradley (born 1868), Sir Frank Brangwyn (1867-1956) and Sir William Rothenstein (1872-1945) who all worked for a time at the Académie Julien in Paris, took their impressions back home with them and so allowed French elements to flow into English Art Nouveau.

However, in France they were less interested in finding points of contact with England. There were of course exceptions such as Louis Anquetin whose painting "Gust of Wind at the Pont des Saints Pères" (1889) shows suggestions of a woodcut by Charles Ricketts and another Frenchman called Alastair whose paintings must have had Aubrey Beardsley's work as a basis.

ART NOUVEAU IN FRANCE

After the heyday of French Impressionism was over, people began to recognize its negative sides, and gradually they felt as if they had reached a dead-end.

Van Gogh wrote to his brother Theo, "People began to talk about brightness and light about ten or fifteen years ago . . . In the beginning it was good, it is a fact that masterly things have been created through this system. But when it degenerates into an overproduction of pictures, in which the white area is dominated in all four corners by the same illumination, the same daylight and the same local colour, as it is called, is that good? I think not."

Other artists thought the same way as him, and it was natural that they considered following a new, more promising direction. While searching for suitable forms of expression they again discovered the Japanese coloured woodcut which had already served the Impressionists as a source of inspiration, but in its formal and colour aspects it still contained a great deal of possibilities which allowed multifarious interpretations. The Japanese influence was, as it were, ageless and could therefore continue to serve European artists as a guide. They were well-advised to orientate themselves to this as can be seen with Henri de Toulouse-Lautrec in the nineties with his impressive and sensational posters which are regarded as a "landmark" in Art Nouveau.

Van Gogh, Emile Bernard and Louis Anquetin who had worked together with Toulouse-Lautrec in Fernand Cormon's studio also drew on the resources of the East-Asian patterns.

"The message of the Japanese woodcut" contains among other things "the stereotyped abridgement for the human figure in silhouette as in portrait, with which the universal is expressed, not the individual inconstant; the same is true for the forms of the landscape, the water, the mountains, trees and flowers. They do not reproduce a visible natural impression which has been translated in two-dimensional picture form, instead they present allegories of life: the short period of blossom of a flower, the quickness of a fish in water, a bird flying completely detached from the earth, the never-ending return of waves and the never-changing duration of the holy mountain

which stands apart from time with its eternal snow covering. You need meditation and contemplation to understand these pictures in which the white of the paper — as the original nothing from which the things are created — is just as important as the drawing itself.

As everything depends on the inner context, the outer context of the natural form can be sacrificed, in fact it has to be given up to create abstractions from the natural form. The various overlapping which the Japanese woodcut shows, even in the representation of human figures, is important for this . . ." (Hans H. Hofstätter)

The artists attempted a simplification in form and colour. It was not important to reproduce the object as such, but what it had to express as well was what the artist felt while observing it.

Emile Bernard (1868-1941) was one of the first who took this path and so rushed towards Art Nouveau. His "Breton Woman on the Grass" from 1888 and his "Stroll along the Lakeside" from 1890 already show a definite form and colour simplification and give a presentiment of the artistic development which was in the offing.

Louis Anquetin (1871-1932) also gained important perceptions from Art Nouveau. He discovered in 1887 that by looking through different coloured glass the emotional mood of nature changed accordingly to the respective glass colour, while the true time of day or prevailing weather conditions played no role whatsoever.

This experience led to monochrome picture compositions which had a special atmospheric content as the artist concentrated on one main colour and its variants.

Van Gogh (1853-1890) was excited by Anquetin's discovery. Several of his pictures were created with a noticeable imitation of his young colleague's work, for example, his harvest landscape embedded in yellow tones.

As well as this van Gogh received many valuable stimulations in those days from his friend Émile Bernard, in fact it seems that he took a great deal of effort to receive Bernard's suggestions. When he did not meet Bernard personally or when they did not work together — as in 1887 in Asnières — he had Bernard's pictures sent to him or at least had his latest works described to him by Gauguin. Infected by van Gogh's enthusiasm, Paul Gauguin (1848-1903) also began to become interested in Bernard's technique. When Bernard

pointed out to him that breaking up colour had a negative effect on the intensity of expression and advocated using only unbroken colour and strengthening the pictorial expression with blue-black contours, Gauguin did not hesitate to follow Bernard's advice and even asked to borrow some colours which he had never used before to test their effect.

Later Gauguin disputed Bernard's authorship of this "Cloisonnism" — the style of painting where areas of colour are surrounded by dark outlines.

For Gauguin the consideration of the younger man's suggestions meant the artistic breakthrough. On the way to his highly personal style, he crossed the path of Art Nouveau and also made a considerable contribution to its popularity.

In the late eighties Bernard and Gauguin had a predilection for working in Pont-Aven, a place in Brittany where the surroundings offered the artistic eye many interesting sights. There they developed their new discoveries further.

Armand Séguin (1869-1903), one of the artists who gathered around the two, characterized the landscape as the spiritual cradle of Cloisonnism which preceded the French Art Nouveau.

In the journal "L'Occident" he wrote, "Brittany facilitates the study of synthesis and Cloisonnism. The countryside lies wonderfully, the stone walls make the fields which they surround stand out; they form red, green, yellow, violet borders, depending on the time of year or day respectively and on the weather; the trees are a black contrast to the sky, the fir tree stands straight, the lopped oak tree reminds us of animals in a fable, the cliffs with the continuous friction of the waves take the form of an unknown monster which they perhaps once upon a time gave shelter to, the tip of a wave forms a white arabesque against the blue of the sea. The whole of nature had spoken to the artists and said, 'See the simplicity of the means I use to show beauty and greatness . . . I have placed strong men and energetic women on this ground: their clothing is austere and is similar to me. The white of the bonnet changes with the black of the costume; when they work, the bending of their silhouettes seems more harmonic to me as it is compensated by the vertical of my lines. The blue of their dress is tuned to the orange of the sand in the same way as the green of my trees and the red of my earth combine; the gold

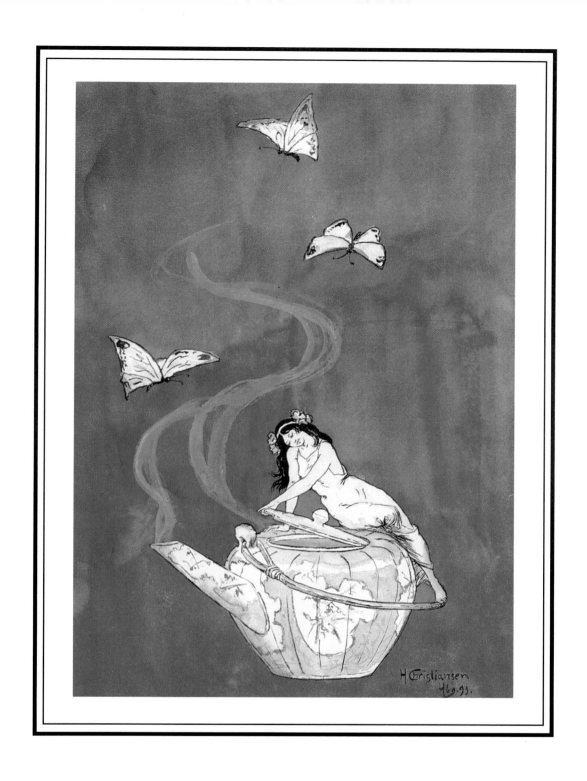

Table I
HANS CHRISTIANSEN
Girl with Teapot. 1893
Watercolor, 46 x 34 cm
Art Collection of the City Darmstadt

of the broom spreads over the violet of the granite. This is the eternal book in which you should read.' ''

And the painters read so intensively that not just they profited from the newly gained knowledge, but also their Parisian colleagues.

When Paul Sérusier (1864-1927) came to Pont-Aven in the summer of 1888, he had Paul Gauguin and Émile Bernard explain their new method of painting to him, and under Gauguin's supervision he painted the river Aven and its banks. "How do you see this tree?" Gauguin asked him. "Is it very green? Then paint it with the most beautiful and strongest green in your palette. And those shadows, do you see them more blue? Do not be afraid to paint them as blue as possible . . ."

Back in Paris, Sérusier presented Gauguin's instructions to his friends from the Académie Julian. They were enthusiastic and decided to form a group which, using the Hebrew name "Nabis" (prophets), followed the example of the Pont-Aven painters and propagated a two-dimensional, colourful and decorative painting style which was less related to objects and more emotional and full of fantasy.

The mystical-religious symbol came to the foreground as a means of expression. With this the Nabis did not intend a complete break with academic tradition. They rather wanted to bring this into harmony with the new style.

Other members of the Nabis, apart from the founder Paul Sérusier, were Maurice Denis, Ker-Xavier Russel, Pierre Bonnard, Edouard Vuillard, H.B. Ibels, Paul Ranson, Jan Verkade and Aristide Maillol.

Every one of them contributed to Art Nouveau painting, but it would go beyond the scope of this book to examine the works of every one of these artists individually. However, outstanding are the book illustratons of Maurice Denis (1870-1943) whose great importance for French Art Nouveau is uncontested. Denis saw book illustration as "decoration of the book with no dependence on the text, but with an arabesque adornment of the pages which accompanies the printed text with expressive lines."

Pierre Bonnard (1867-1947) and Edouard Vuillard (1868-1940) are mostly mentioned in one breath as their art was characterized by similar aims and intentions. Both resisted the mystic-religious form

ideas of the other Nabis. For them the poetic-decorative stood in the foreground of their endeavours.

Bonnard used the Japanese woodcut pattern more than the other Nabis which gave him the nickname "Japanese Nabi". He and his friend Vuillard touched on Art Nouveau, but soon overpassed it.

Without being a member of the Nabis, the Swiss Félix Vallotton (1865-1925), who had lived in Paris since 1882 and had also attended the Académie Julian, showed an active interest in the group's work and even exhibited together with them.

Vallotton developed from the woodcut which he never renounced in his painting work. His approaches to Art Nouveau and the late Symbolism made him a forerunner of the "Neue Sachlichkeit" (New Objectivity).

As well as this there were artists in France and other places who included Art Nouveau in their work — mostly with ties to applied arts. However, because of an artificial interpretation which did not suit their true intentions in the long run, they brought it slowly but surely into disrepute. On the other hand artists of the following generation such as Pablo Picasso (1881-1973) were eminently capable of putting a few highlights into the fading Art Nouveau in their early work before going on to new horizons.

Picasso once said, "We were all Art Nouveau artists. There were so many wild, crazy curves on these Metro entrances and other Art Nouveau works that I rebelled against it and limited myself completely to straight lines. However, I was still a part of Art Nouveau in my own way. When you are against a movement you still remain a part of it. In the final analysis for and against are two aspects of the same movement."

Another foreigner felt bound to the French Art Nouveau: the Norwegian Edvard Munch (1863-1944). "His art even convinced the opponents of Art Nouveau," wrote the art historian Hans H. Hofstätter in 1963 in "History of European Art Nouveau Painting", "because a human experience is painted in every picture and because the viewer can have an empathy for this experience even when it has been so subjectively witnessed . . ."

In 1885, Munch made his first trip to Paris, where in 1889 he was able to study for four months with Léon Bonnat thanks to a state-financed grant. Through Impressionism he found his way to Art

Nouveau after another temporary stay in Paris in 1895 when he got to know van Gogh, Gauguin, Toulouse-Lautrec, Bernard, Séguin, Denis and Sérusier.

"But with the adoption of motifs and style features the transposition into a different spirituality is immediately obvious. For example, Munch adopted the limbless, unmodelled silhouette — like figures which Bernard had developed since 1890. However, with Munch this form expresses something else: The contour becomes a prison for the figure in which it remains captured . . . Also Bernard's overlapping peripheral figures which look directly at the observer are used by Munch, but in a completely different context. With Bernard they were the fulcrum of the composition, the connection to the viewer, but with Munch their looking out of the picture is more visionary: with their inner eye they see what is happening behind their backs . . ." (Hans H. Hofstätter)

ART NOUVEAU IN SWITZERLAND

In Switzerland there were only a few artists who dedicated themselves to Art Nouveau painting subsequent to the new development in France. The main representatives were Ferdinand Hodler (1853-1918) and Cuno Amiet (1868-1961).

Hodler came from Berne and first began an apprenticeship with a landscape painter from Thun before studying from 1871-1876 at the Ecole des Beaux Arts in Geneva.

In 1890 his first symbolist picture "The Night" caused a scandal in Geneva, but the following year at an exhibition in Paris it was well received. Because of this exhibition the artist remained in Paris for a time, where he got to know the Nabis and works by Puvis de Chavannes. This gave him a lot of new ideas that brought him closer to his aim of creating monumental paintings.

Ornamental lineation became from then on one of his most important means of expression. Hodler developed to Art Nouveau and Symbolism from a realistic and naturalistic style of representation. In his monumental compositions he attached great importance to symmetry of picture and parallelism of form. That meant rhythmic form repetition, as he thought, "We all have our joys and our pains, each of which is just a repetition of the other and which are only obvious to the outside by the same of analogous gestures."

During a stay in Paris, Cuno Amiet was introduced to the Nabis by Félix Vallotton. Through them he came to Pont-Aven where he got to know Émilie Bernard and Armand Séguin.

The impressions he gained there and the recognition of the new style were decisive for his art from then on. He painted large format landscapes with yellow and orange as the main colours.

After his return to Switzerland Amiet was also influenced by Hodler. Hodler's style corresponded with Amiet's desire for the decorative-ornamental so that a monumental accent became obvious in his work from then on. Apart from landscapes and figure paintings Amiet also created still-lifes and portraits.

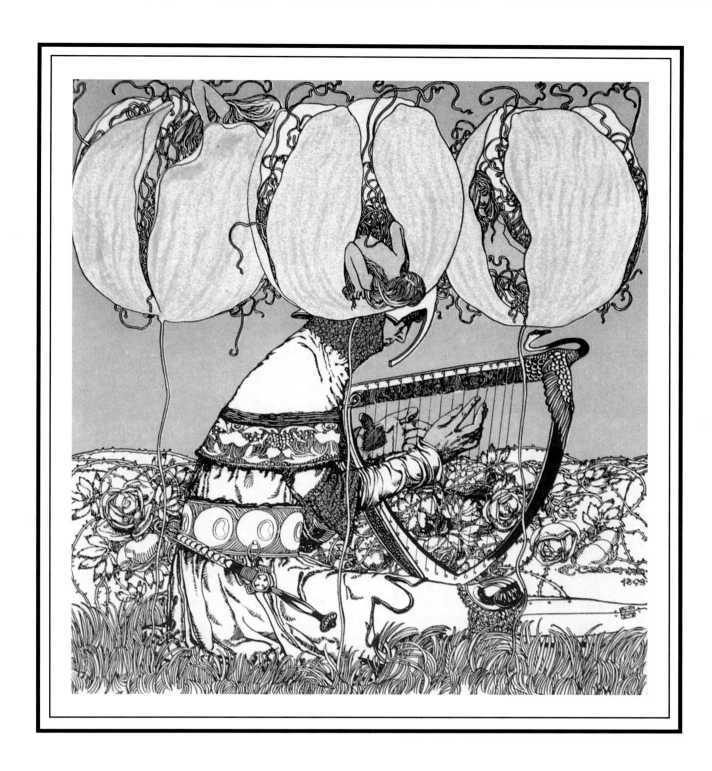

Table II
CARL OTTO CZESCHKA
Music. 1898
Colored drawing
Galerie Michael Pabst, Munich

Giovanni Segantini (1858-1899) from South Tyrol, another artist who felt close to Swiss Art Nouveau painting as he had found a second home in this country, said, "I was no longer content with realizing my previous ideas about the harmonious expression of colour, but instead I tried to reproduce sensations which I felt, especially in the evening after sunset, when my soul placed itself in a state of sweet melancholia." Birth, life and death were the motto of his representations.

ART NOUVEAU IN GERMANY

In Germany, Art Nouveau first made its appearance long after it had become popular in England, France, Switzerland, Belgium and the Netherlands. Because it had evolved from historicism, the artists at the time orientated themselves more to developments in England and the Netherlands than to France where Art Nouveau had come from Impressionism.

Almost all of the German painters who turned to the new style dedicated themselves at the same time to commercial art, interior design or architecture. In this way they differed a lot from their colleagues in other countries.

Important centres of art at that time were Berlin (Klinger, von Hofmann, Leistikov), Darmstadt (Christiansen) and Worpswede (Modersohn-Becker, Modersohn, Vogeler). The artistic metropolis was, however, Munich, with Franz von Stuck (1863-1928) as its most significant representative.

Stuck, the "painter prince" and "Grand Seigneur of the palette" as he was often called, came from Tettenweiss in Lower Bavaria. His family was poor but when he was just five years old, he showed such a talent for drawing that his mother was, even then, convinced that one day "something great would become of him."

She was to be proven right. Stuck experienced a meteoric rise to fame. The Munich Academy of Applied Art where he studied pro forma from 1881-1885 made him professor in 1895. During his studies he had in fact been teaching himself, especially from works by Julius Dietz, Arnold Böcklin, Franz von Lenbach and Hans Holbein the Younger. He also became vice-president of the "Neue Sezession" and prince regent Luitpold of Bavaria even raised him to the nobility in 1906.

Franz von Stuck was a very versatile artist who proved his abilities not just as a painter, graphic artist and cartoonist but also as a sculptor, craftsman and architect.

In his paintings, his preferred themes were mythological, allegorical and erotic representations. He often combined Art Nouveau and Symbolism.

Stuck painted in a style which was understood and admired by his contemporaries so that the theme "sin", which he interpreted several times, was not even regarded as offensive.

A critic wrote about Stuck's "Bacchanalia" (1905), "The sensual glow of the dance, seeking and finding the dancers, the flowing together of the hot sensations, the complete mutual surrender is, in this simple form language, really unique in our art."

Carl Strathmann (1866-1939) had a more difficult position than Franz von Stuck. The artist first studied in the academy in his hometown in Düsseldorf and then with Leopold von Kalckreuth in the art school in Weimar before arriving in Munich at the beginning of the nineties. He was brought into contact with Art Nouveau through an exhibition with works by Jan Toorop from the Netherlands and Aubrey Beardsley from England.

Besides fairy-tale like landscapes, decorative figural compositions were close to Strathmann's heart. He combined painting and the crafts so much that he even glued or sewed imitation precious stones onto his pictures to increase the decorative effect.

At first public and critics registered such novelties with indignation. Strathmann's most famous work "Salambo" was rejected by the Munich Kunstverein because of its "craftlike" character.

In 1903, Lovis Corinth described how Strathmann went about his work, referring to "Salambo", ". . . The woman was to lie dreaming on the daybed, completely naked, a harp beside her head. A model was hired, and everyone who wanted to hear it was told by Strathmann that he would surpass Dürer and Holbein with the correctness of form. But soon the model was sent home and gradually he covered the nakedness of his Salambo with rugs and fantastic robes so that in the end only a mystical profile and the fingers of one hand looked out of a tangle of material decorated with ornamentation . . ."

This method of working was typical for Strathmann. The artist loved to cover "his pictures with a rug-like ornamental pattern of extreme detail and unbelievable wealth of motifs." (Hans H. Hofstätter) Every detail was embedded in the composition with artistic tenderness.

It was a truly effective effort which is still fascinating for the observer today.

In 1899, twelve students from the Munich Academy formed an artistic association which they called "Die Scholle" (The Soil). The name was "meant in the sense of spiritual independence" as their spokesman Fritz Erler (1868-1940) stressed. He said, "Now I understood for the first time what it means 'to defend one's soil'."

Most of the "Scholle" members worked as illustrators for the journal "Jugend" which is often described as the source for the name of the new style, i.e. "Jugendstil", even if it was by no means just Art Nouveau works which were published in it.

Fritz Erler and his colleague from South Tyrol Leo Putz (1869-1940) were the prominent Art Nouveau painters in the group. Both of them had studied for a time at the Académie Julian in Paris and were very familiar with works from the Nabis and Toulouse-Lautrec. This undoubtedly had a lasting effect on their further development and was also one of the reasons for their turning to Art Nouveau.

However, this did not mean that both artists were in accordance with each other. On the contrary, Erler and Putz had completely different temperaments.

Fritz Erler loved the monumental. In 1905 Hans Rosenhagen, a contemporary of Erler described his woman type as ". . . a strong, powerful creature with a full figure, with cold eyes and voluptuously curved, sensual lips, and with the movements of a goddess. A conqueress, a woman who becomes mistress in the fantasy of a weak man, someone who he lets mistreat and kick him. The heavy, melancholic-sultry figure of this woman with her composed movements is surrounded by ruthless sensual tones of grey, yellow and violet . . ." Leo Putz formed the cheerful, fairy-tale-dreamlike contrast. The art critic Karl Schloss wrote a very fitting comment on him. "Putz paints us, as it were, the vowels of the language of colour."

Peter Behrens (1868-1940) who worked in Munich, Berlin and Darmstadt made himself a name as painter, graphic artist, craftsman, illustrator and architect.

His "Kiss" (1897), a coloured woodcut, in which both the faces, which are forced to the middle, are flattered by linear ornaments, is a typical example of German Art Nouveau.

Even Franz Marc (1880-1916) and Wassily Kandinsky (1866-1944) were inspired by Art Nouveau in their beginnings. Kandinsky, who

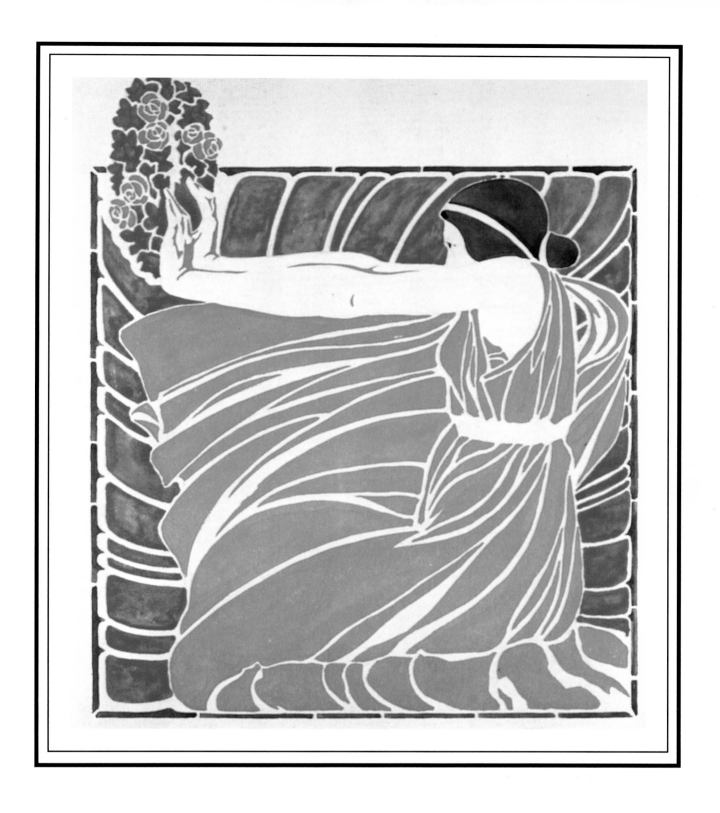

Table III
FRIEDRICH KONIG
Kneeling Woman with Red Garmet. 1905
Watercolor, 22.2 x 18.2 cm
Galerie Michael Pabst, Munich

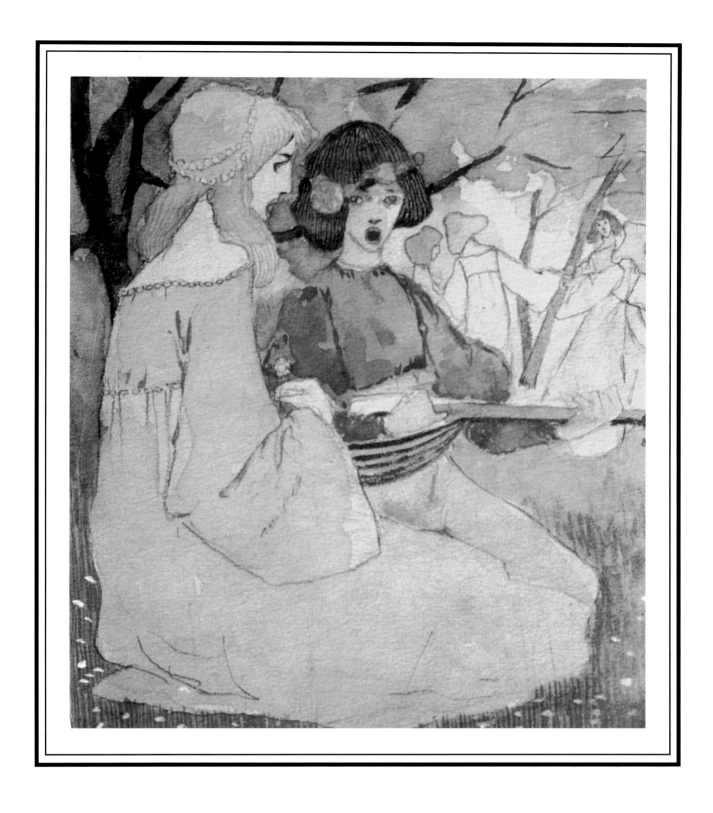

Table IV
HEINRICH VOGELER
Folk Song. Ca. 1900
Watercolor, 17.5 x 15.8 cm
Private Collection

studied under Franz von Stuck, the Munich master of Art Nouveau, said of his tutor, ". . . He talked unexpectedly affectionately about art, about the play of forms, about the flowing together of forms and won my full sympathy . . ."

However, Kandinsky did not just have Stuck's theories and his Art Nouveau work in mind when he painted "Russian Beauties in the Landscape" (1905), "The Colourful Life" (1907) or similar pictures. He felt an echo of the Russian saga and fairy-tale world. In this way he brought the traditions of his homeland into harmony with the international art movement at the turn of the century and conveyed Russian ideas into German Art Nouveau.

The first simplifications of form which Kandinsky carried out in his Art Nouveau works were the starting point for his non-representational art of later years.

"I have mentioned in many places that the subject in itself forms a certain spiritual tone which, as a material, can and does serve art in all areas," he wrote about his attitude in those days. "And I was still too closely concerned with the desire to seek the purely artistic forms with this spiritual tone. I more or less dissolved the subjects in a painting so that they could not all be recognized at once in order that these spiritual overtones could gradually be experienced by the observer, one after the other."

In Berlin eleven artists formed a group on February 5th, 1892. They were simply known as the "Eleven". Among them were the main representatives of Art Nouveau painting in Berlin: Max Klinger (1857-1920), Ludwig von Hofmann (1861-1945) and Walter Leistikov (1865-1908).

In the first two exhibitions which the "Eleven" organized in the same year as their foundation, the artists were faced with rejection by the public and the press and even by the Emperor. William II was shocked because this style of painting presented "misery even more awful" than it already was.

Max Klinger's art is as varied as it is contradictory, as the painter, graphic artist and sculptor sensed the irresistable urge to absorb numerous stimuli and to include them in his work. This led partly to a confusing abundance of different elements of style which was not exactly beneficial to a clear conception.

But the public were enthusiastic about his compositions, as Klinger deliberately avoided revolutionary excesses and adjusted himself so much to public taste that Max Friedländer wrote in the magazine "Kunst und Künstler" in 1917, "This master has satisfied several preconceptions, tendencies and demands of the German public so completely that the suspicion is aroused that he set himself up as a charlatan to accommodate these instincts." But at the same time Friedländer invalidated this awful suspicion by stressing, "Such mistrust is unfair, Klinger was always honest and true, in his own way even naive. His creation grew organically from his original talent . . ."

Max Klinger, "a philosophical, ruminating spirit, filled with a strongly ethical emotion", as he was characterized by Hans Hildebrandt, constantly hovered between idealism and naturalism, but he gave Art Nouveau decisive accents.

"There are paintings by Klinger such as his "Blue Hour" where all the objects and figures are submerged in the fading light of evening, where the figure is no longer painted in light but instead the reflection of light on the human figure is equal to reflections from its innermost; the three female nudes express different spiritual attitudes in dumb contemplativeness. Here academic painting is combined with the emotions of Art Nouveau . . ." (Hans H. Hofstätter)

Like his French colleagues, Klinger made intense considerations of the art of Japanese woodcuts. This benefitted his decorative, graphic Art Nouveau work much more than his painting.

Ludwig von Hofmann was four years younger than Klinger and came from Darmstadt. He studied in Dresden, Karlsruhe and Munich before moving to the Acadèmie Julian in Paris in 1889 and in 1890 to Berlin.

His preferred themes were bathers, dancers and people resting. His favourite motifs were boy and girl nudes in a pastoral scene.

"The modern yearning for a paradise lost, the dreaming back to lost worlds of beauty found its purest expression in him. His people are children who know no evil, children who show amazement at the sun's rays, at the rippling stream, to whom all of nature and their own existence is a wonder . . . young men and girls, naked and shy, rest, undemanding and with no passions in green meadows or offer a hand to dance," wrote Richard Muther in 1899.

Ludwig von Hofmann tried to achieve perfect beauty in his art. In his works, people and nature melt together to one unit, and the bodily movements of his dancers were given so much grace that Hugo von Hofmannsthal, who wrote the prologue to a series of lithographs by the artist in 1906, whose works he compared to Mozart's sonatas, stood up for Ludwig von Hofmann's creations with all the exhuberance of his feelings. "Their unity is in the rhythmical joy which they emanate and which the soul is so ready to absorb through the eye as well as through the ear. These figures narrate nothing but their nakedness; they fill the picture area rhythmically and the power of imagination can play them through to the end, page for page, and weigh itself on them, as on any series of blissful tones . . ."

Walter Leistikov's attempts at expression were manifested in the area of landscape painting. He was especially attracted by woods and lakes.

In the beginning he was bound to a traditional style of painting, but became increasingly more liberated in his design and after a short stay in Paris in 1893, he also began to include symbolistic elements in his landscapes until eventually he arrived at a monumental, decorative representation of nature.

He also worked in the area of commercial art and was a committed writer on contemporary art.

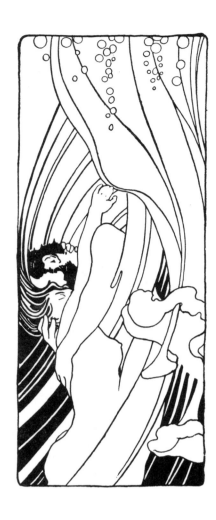

THE VIENNESE CONTRIBUTION

In Austria, Art Nouveau was especially bound to the capital, Vienna. Among the artists who did the style a great service were Anton Romako, Koloman Moser, Maximilian Lenz, Friedrich König, Egon Schiele and Oskar Kokoschka. The last two mentioned were pupils of Gustav Klimt "the bearing force of Viennese Art Nouveau." (Hofstätter)

As in Germany, the new style developed from historicism and, as in Munich, was bound to the foundation of a Sezession. This "Association of Austrian Artists" (1897) had given itself the task of enforcing real art against pseudo art." (Hofstätter) Their president until 1905 was Gustav Klimt (1862-1918).

The artist, who came from humble origins, made up for his lack of education with talent and ambition. In the course of time Klimt gained a comprehensive range of knowledge which enabled him to gain a foothold in society.

Apart from his tutor Ferdinand Laufenberger, Hans Makart was his most important example. The so-called "Makart style" was in those days more or less synonymous with history painting.

Like Carl Strathmann, Gustav Klimt also turned to craft media. For example, he glued golden paper onto his pictures which gave them an especially three-dimensional appearance.

He was a master of the symbolic ornament, although many of his contemporaries had difficulties dealing with the strong tendency to abstraction. His three ceiling paintings for Vienna University "Philosophy", "Medicine" and "Law" (1900-1903) caused a public scandal. Klimt also had to suffer the accusations that his work was pornographic. But his work was above narrow-minded reactions of this kind, especially as the understanding of a work of art is to a great extent, dependent on the individual way of seeing it. A critic made a very fitting remark after seeing one of Klimt's paintings, "The picture is . . . depending on the position the viewer takes, wicked or adorably modern."

As opposed to Klimt, Rudolf Jettmar (1869-1939) felt tied to the academic traditions of the 19th century and developed his work, whose main motif was man, from a combination of naturalism and symbolism.

The artist reported on his rather unusual working methods, "When something concerns me, when I have read or seen something, I lie down afterwards until I am completely relaxed. Suddenly I have the picture in front of me, I don't see it, I grab it and attempt to probe it. Then I have to get up — sometimes it is late at night — and capture it with a few lines, otherwise it is gone."

In the various countries there were magazines which propagated the ideals of Art Nouveau. Vienna had "Ver Sacrum", Germany the "Jugend", "Simplizissimus" and "Pan", France had the Parisian "Revue Blanche" and in England there were "The Yellow Book" and "The Studio".

Considering the number of countries involved in Art Nouveau — apart from those mentioned here there were also Holland, Belgium, Finland, Italy, Spain, Hungary, Poland and Russia — and the number of artists who distinguished themselves in this style, it is not surprising that Art Nouveau painting found the most varied forms of expression and that it is difficult to talk about a unified style. But perhaps it is the variety of possibilities which impressed its brand on the whole epoch with all of its widely branching areas which is the interesting and unique in Art Nouveau which, of course, also had its opponents.

For example Emile Zola spoke strongly against it in 1896, "Your works have a touch of mouldy cellar air, which is never flooded by warming sunlight; they are imbued with ambiguous lewdness; your religion has something squint-eyed about it and is based on intellectual and moral depravity. Go away with your lilies, your female figures which are so thin that you can almost see through them. They are just souls and would melt like schemes with a proper masculine embrace. Serve the world more of this until they have had enough and turn away, and do not be sparing with the symbols! The more muddled they are the more they lead humanity into confusion. Carry on! The more lilies you sow the more the crops will grow from which humanity draws its proper nourishment.

If I tenaciously speak up for positivism, I know exactly why I do it. It alone protects us from the spirits becoming absent-minded; it alone protects us from that sort of idealism which bears the worst, unforeseeable decay. Look at where you have already landed! Mysticism is your hobby, mystery-mongering and imagining all kinds of frightening ghosts have become your daily bread. You follow a reli-

gion which believes in the devil, you want love which wants to know nothing about children. Truly the peoples who have lost their belief in life and exchanged it for the gloomy madness of mysticism are wasting away . . . That is what separates us, has to separate us forever. It is our opinion on humanity, on women, on life, on truth. We will make a break because of this — for ever!"

Kandinsky who had come from Art Nouveau himself only saw its negative sides as soon as he had developed further. He regarded the stylized form as "weak", the ornamental form as too expressionless to have a future and in the experimental form he saw a danger because he thought it "arises in an experimental way, in other words completely without intuition like every form that has a certain tone which simulates the inner necessity."

This argument might be good and correct, but Art Nouveau definitely fulfilled its task as a link between art of the 19th and 20th centuries. Even those who — like Kandinsky — later denied that it evened the way for Expressionism, in fact that Expressionism emerged from Art Nouveau, benefitted from the movement.

ILLUSTRATIONS

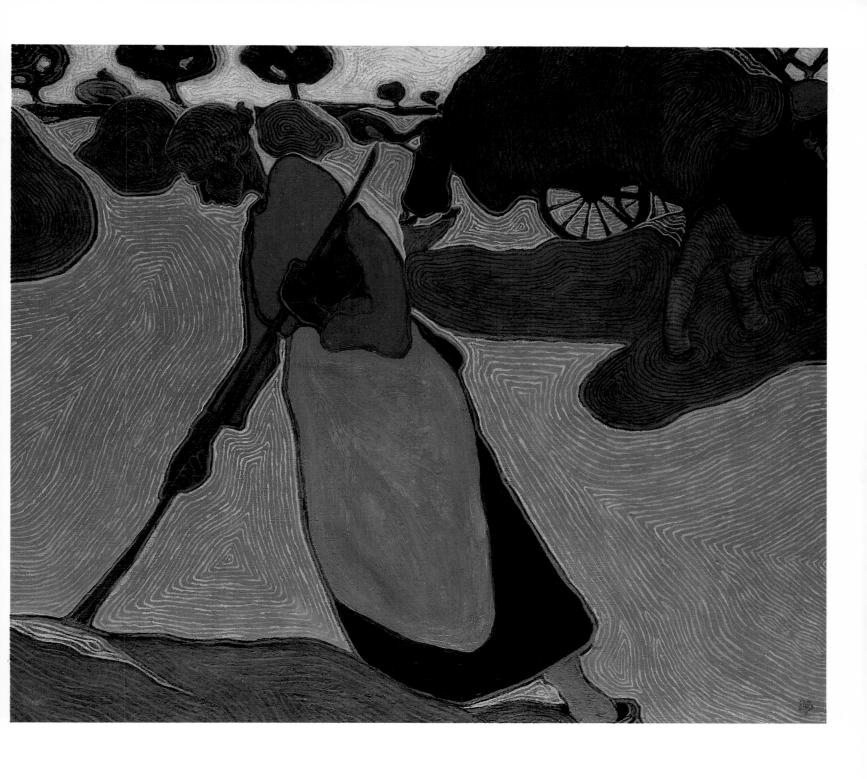

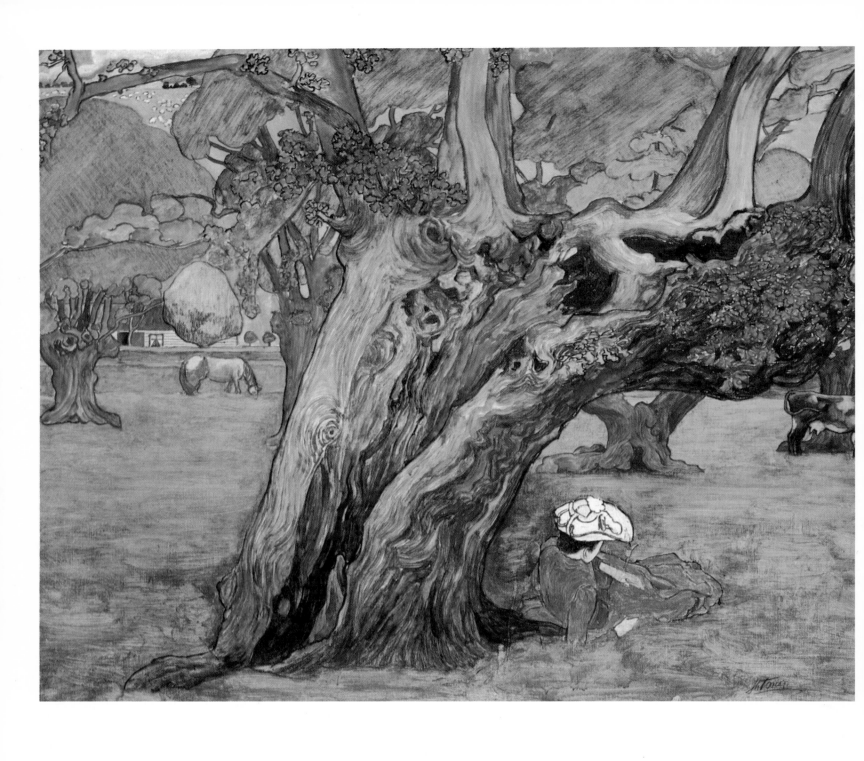

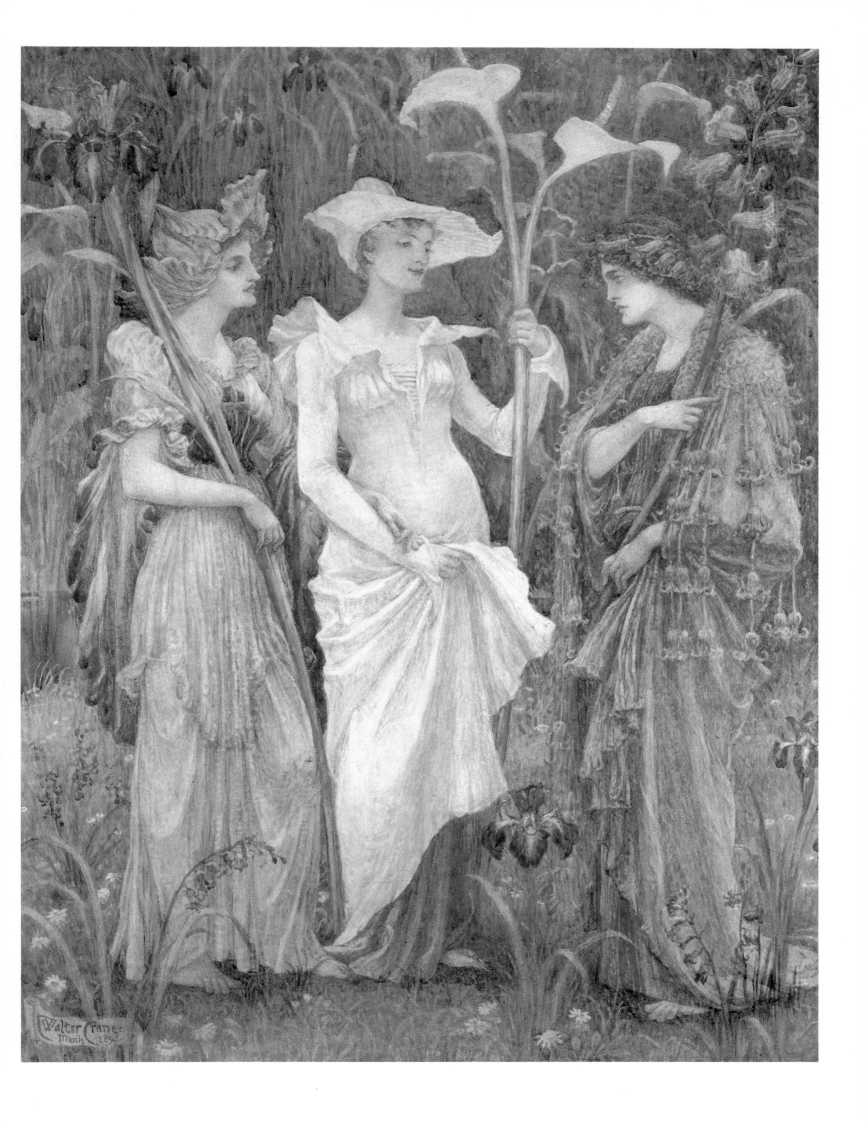

35

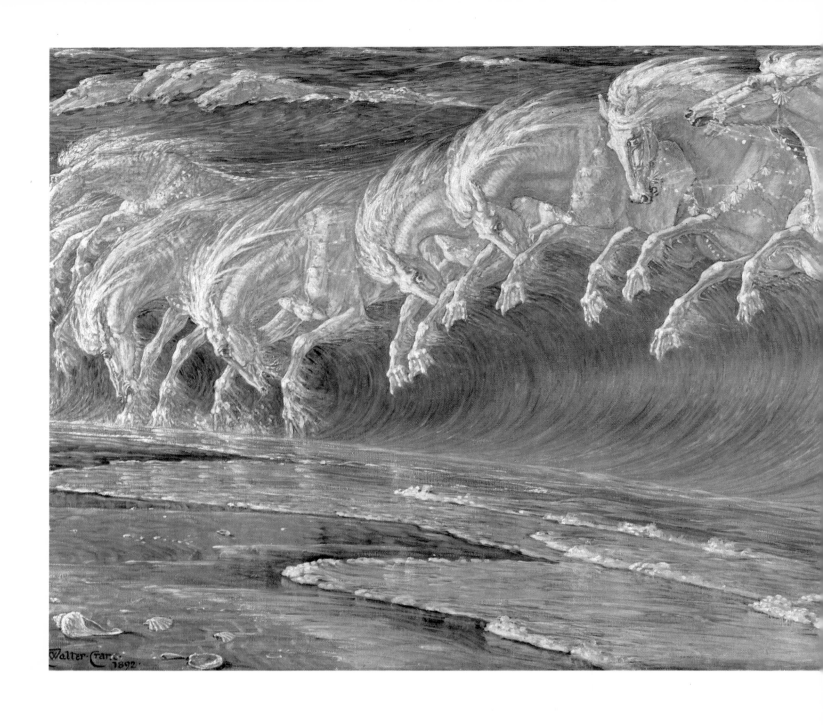

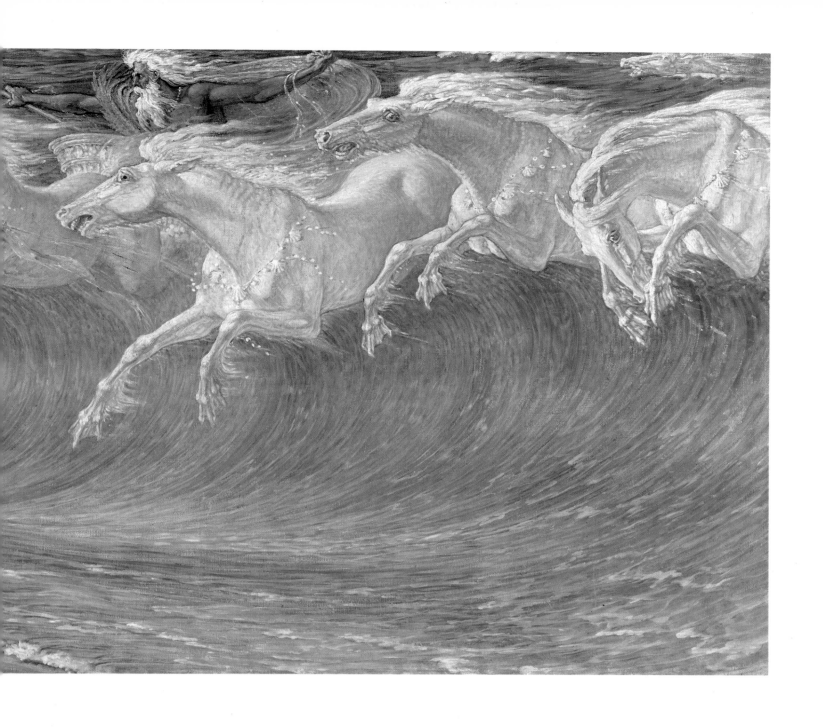

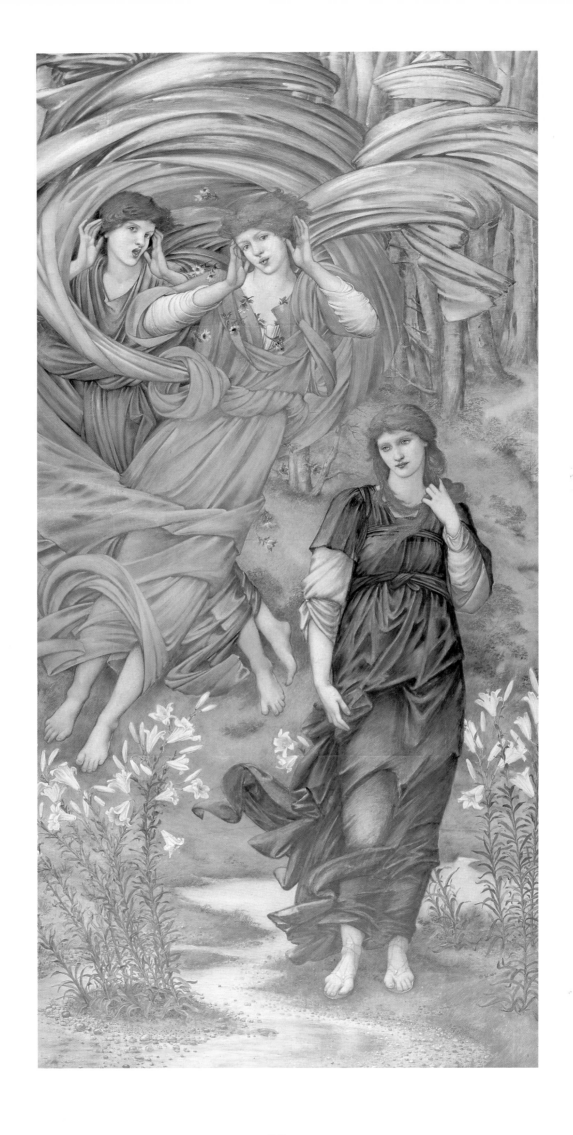

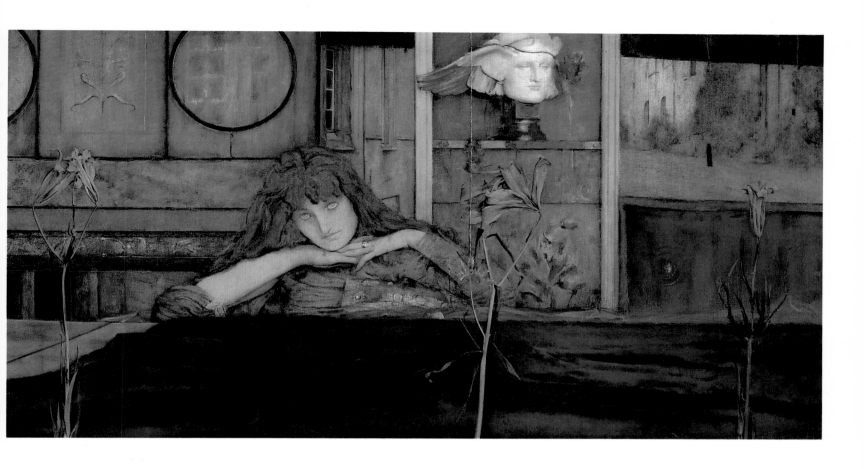

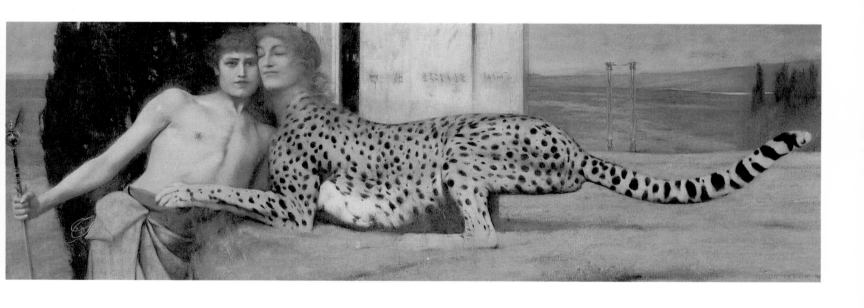

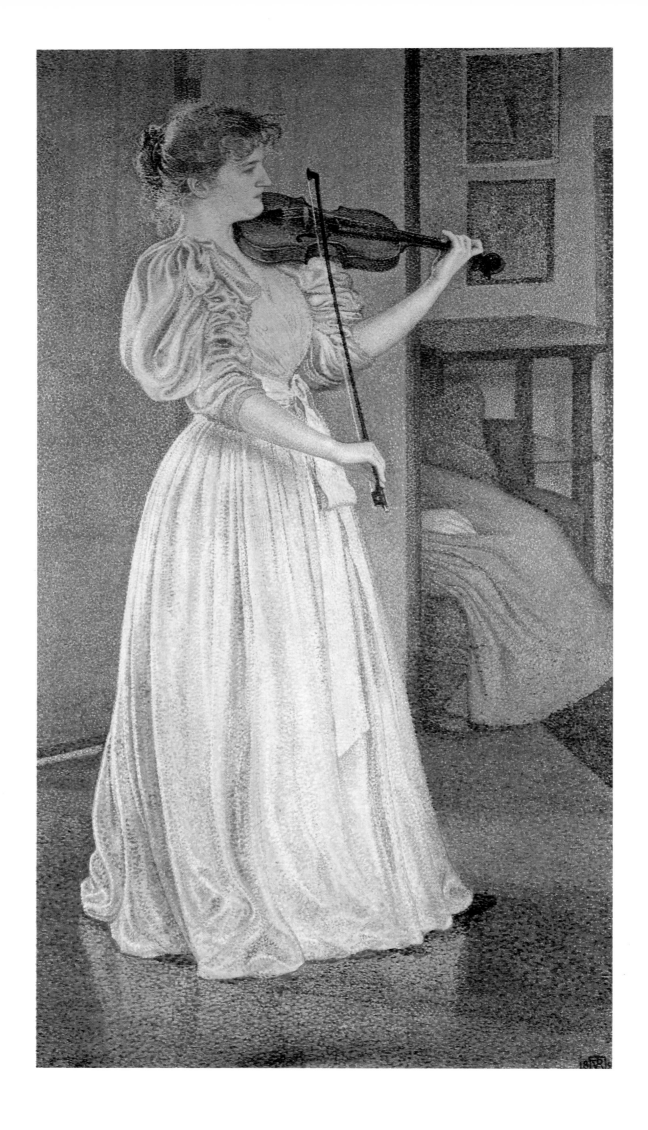

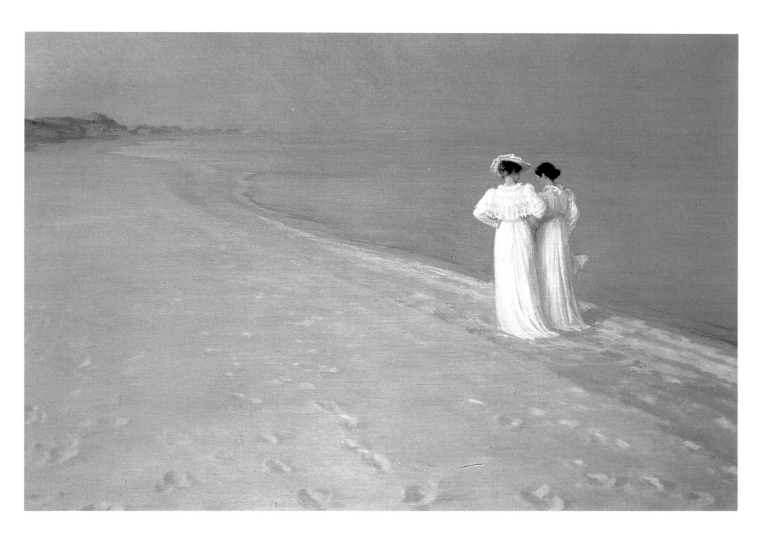

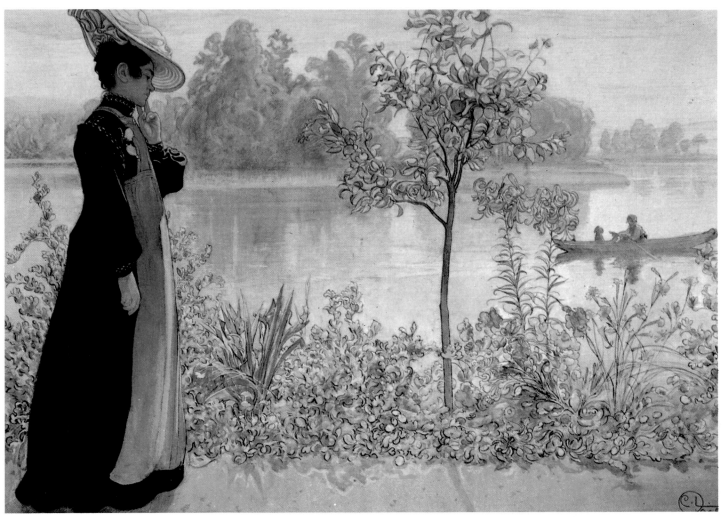

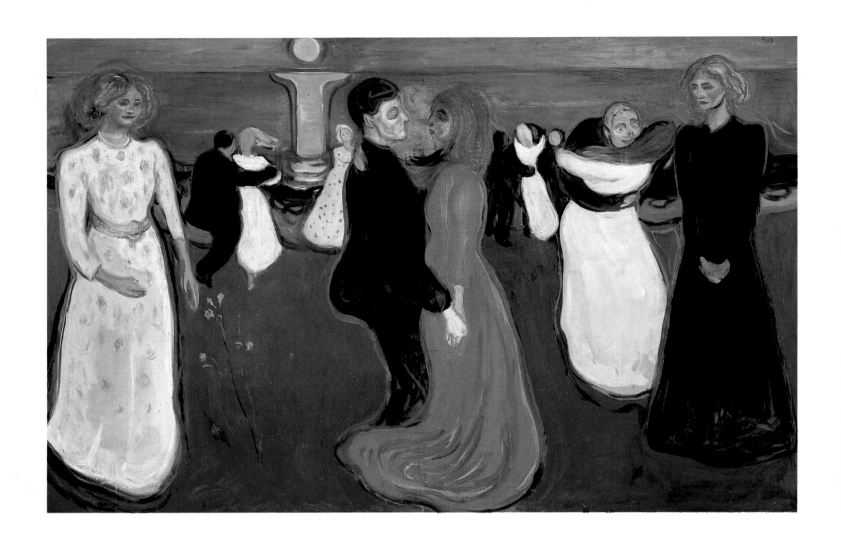

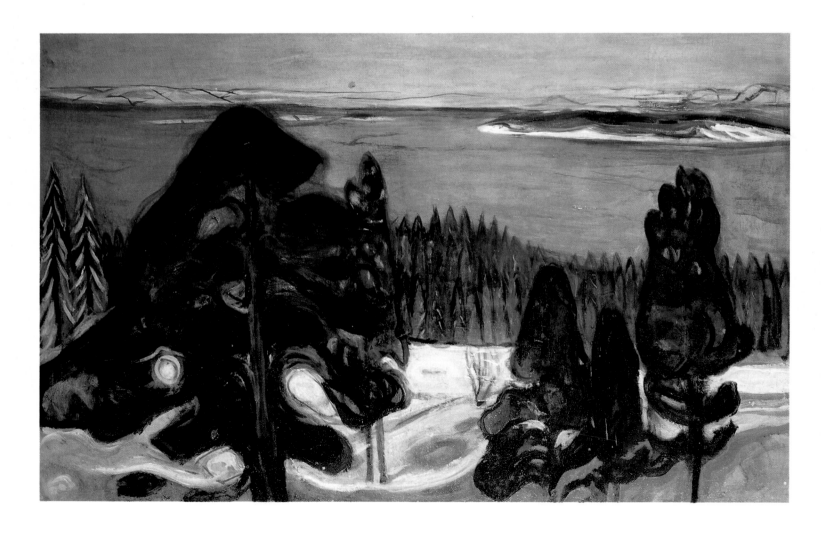

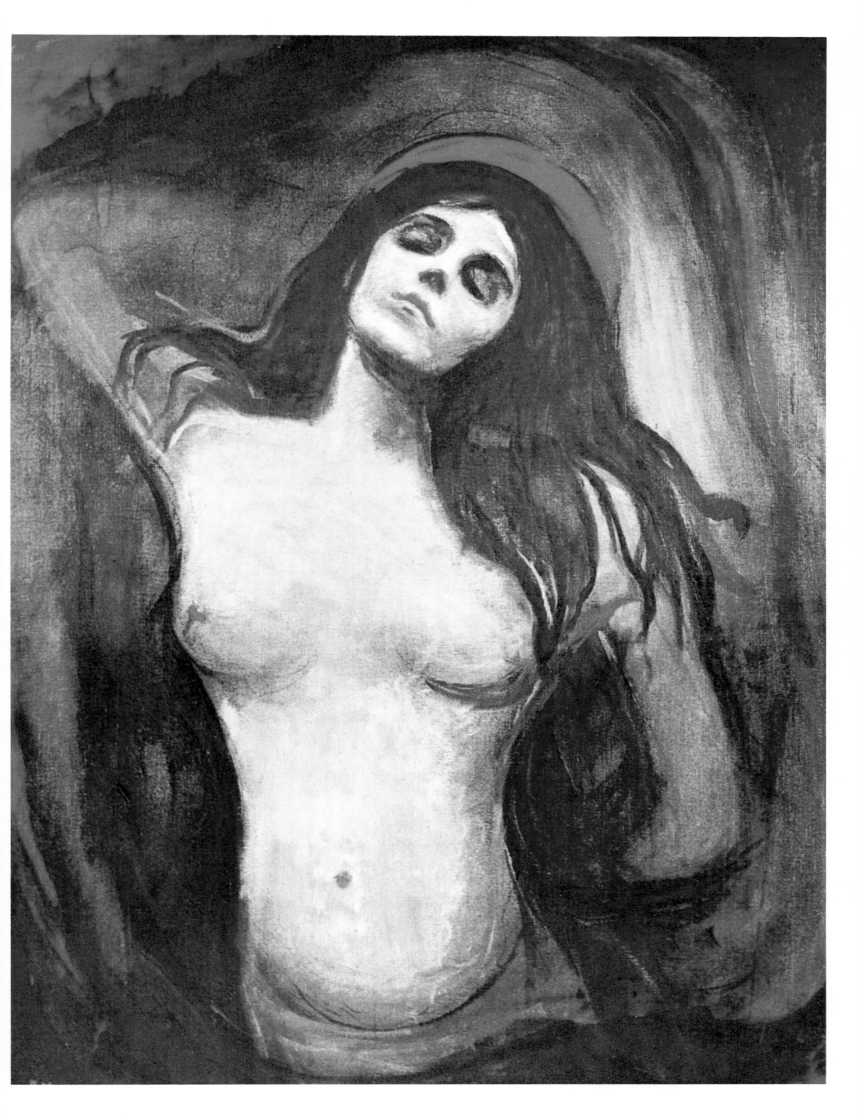

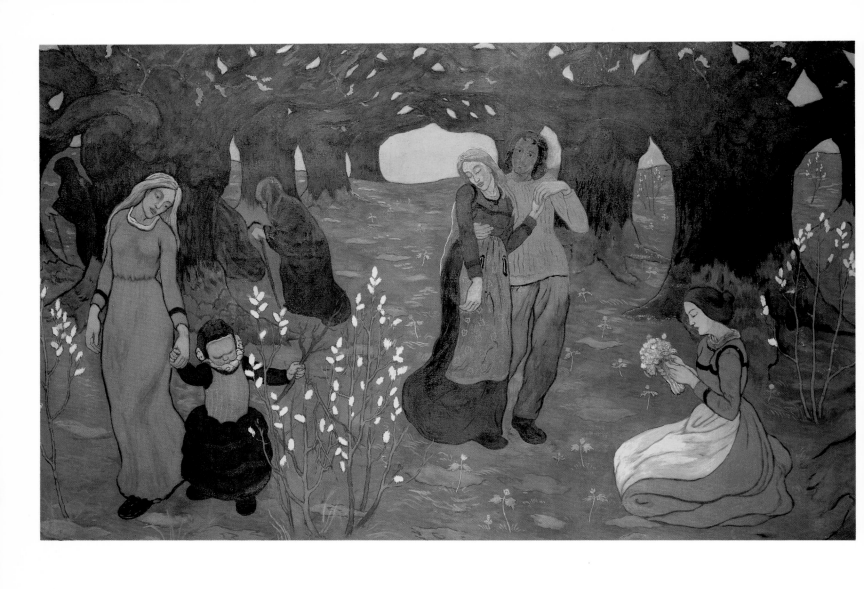

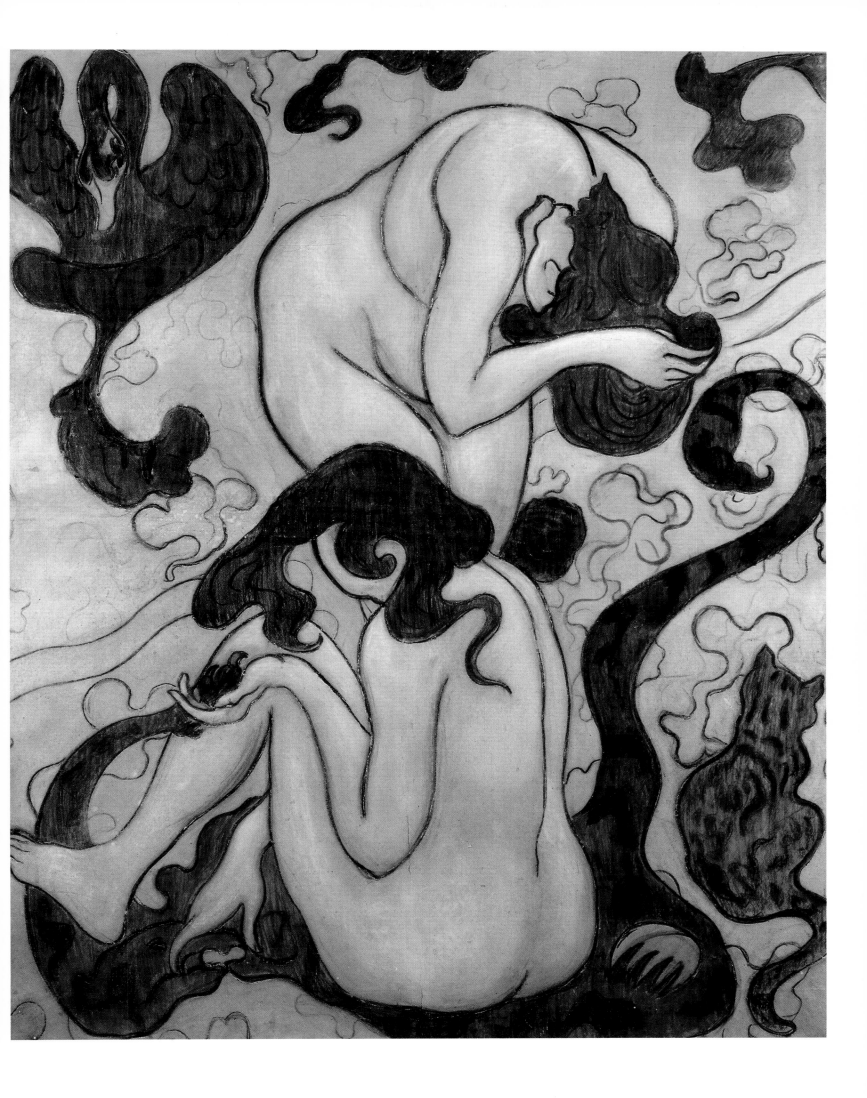

45

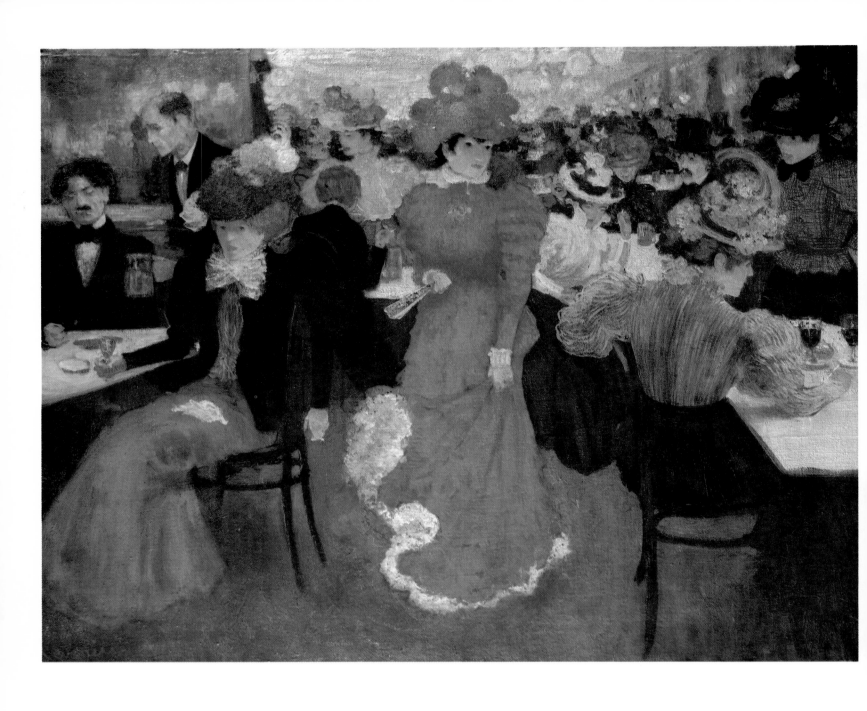

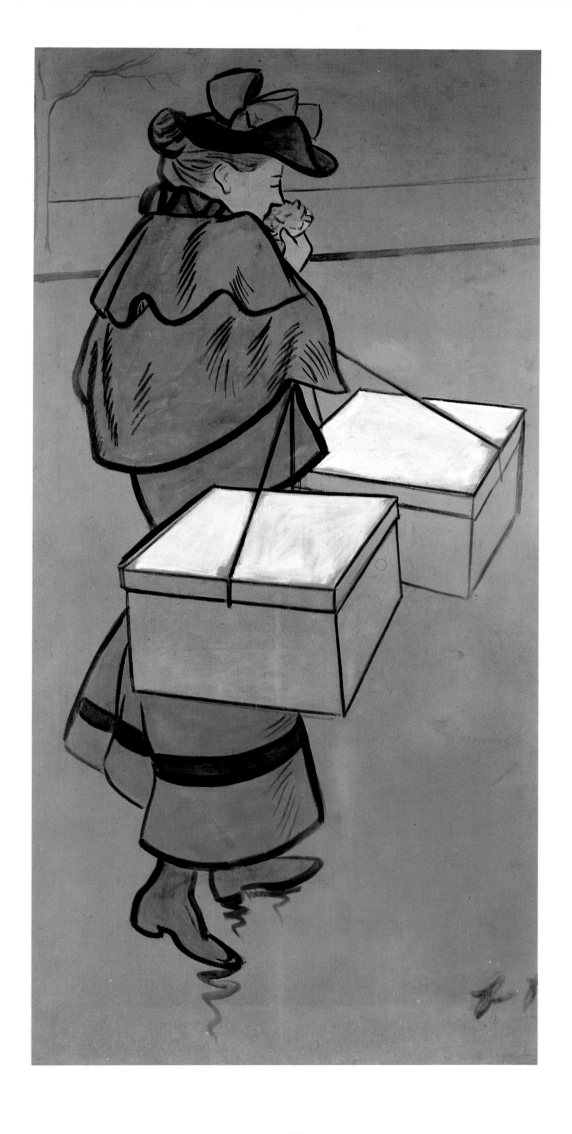

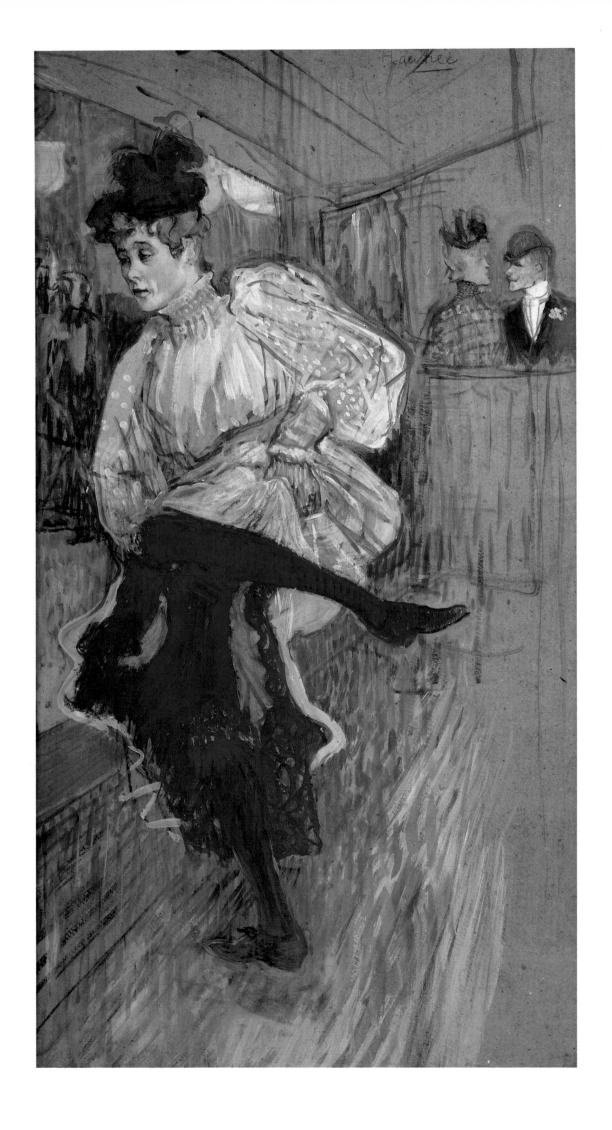

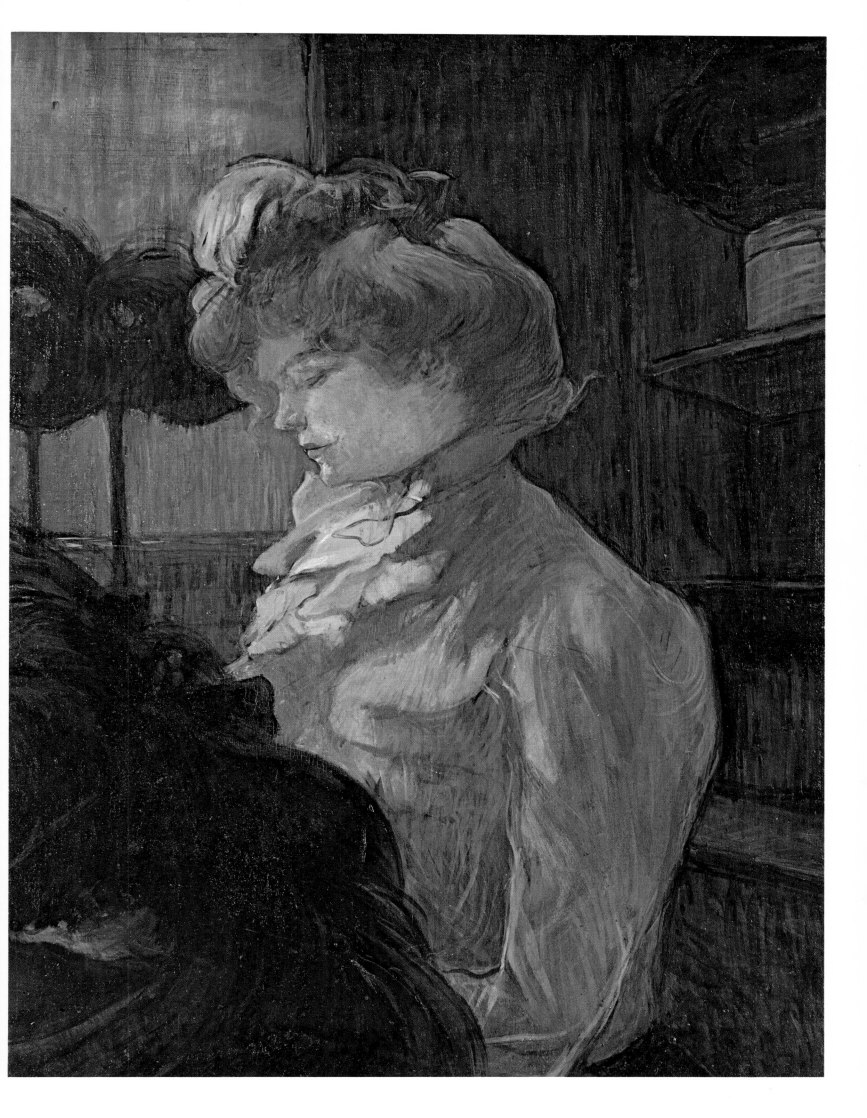

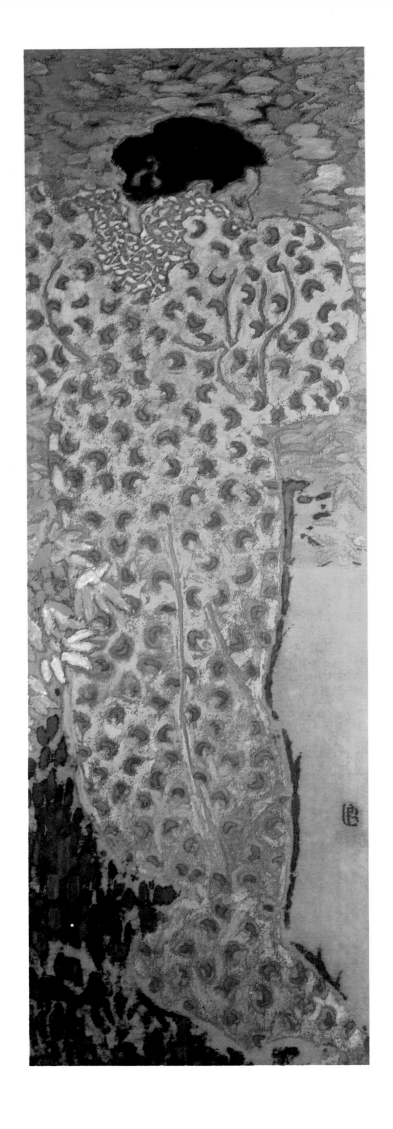

50

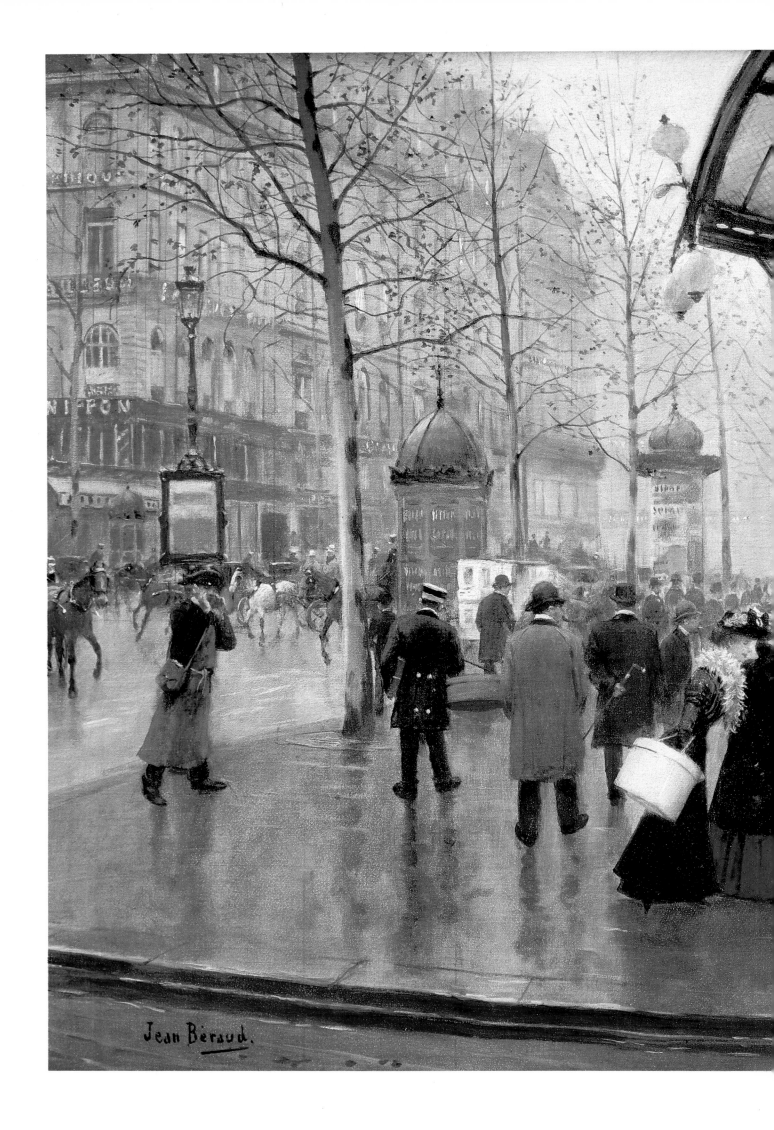

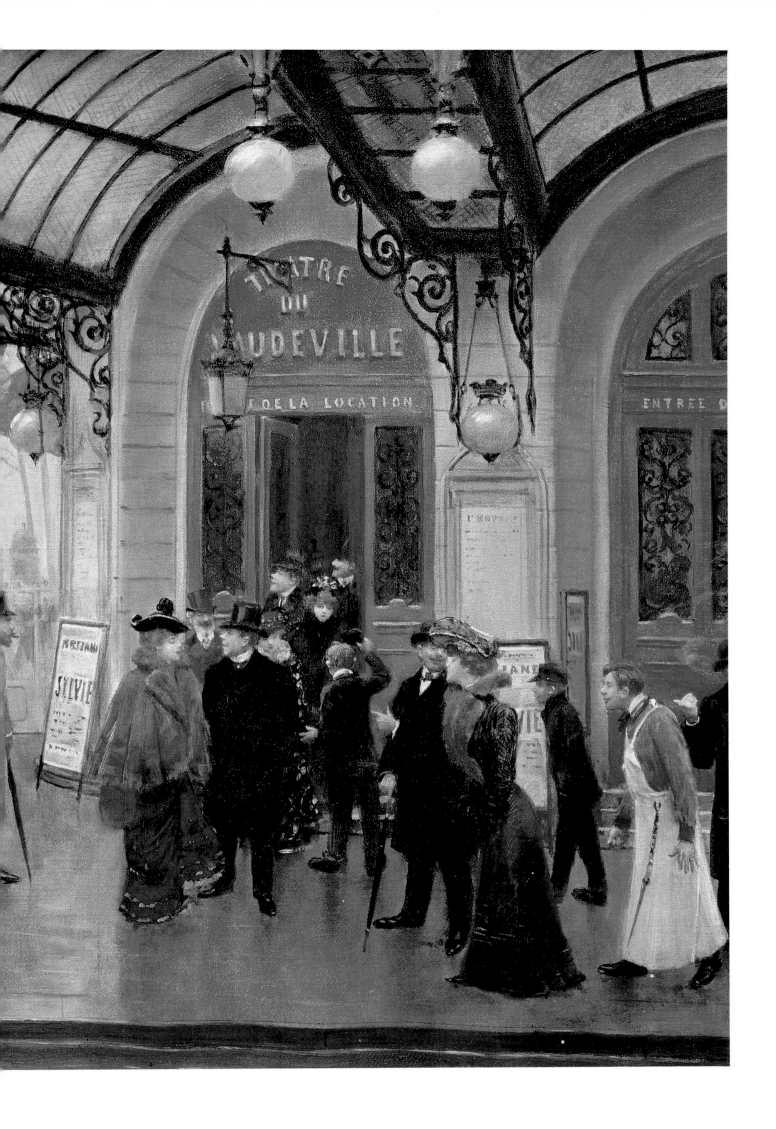

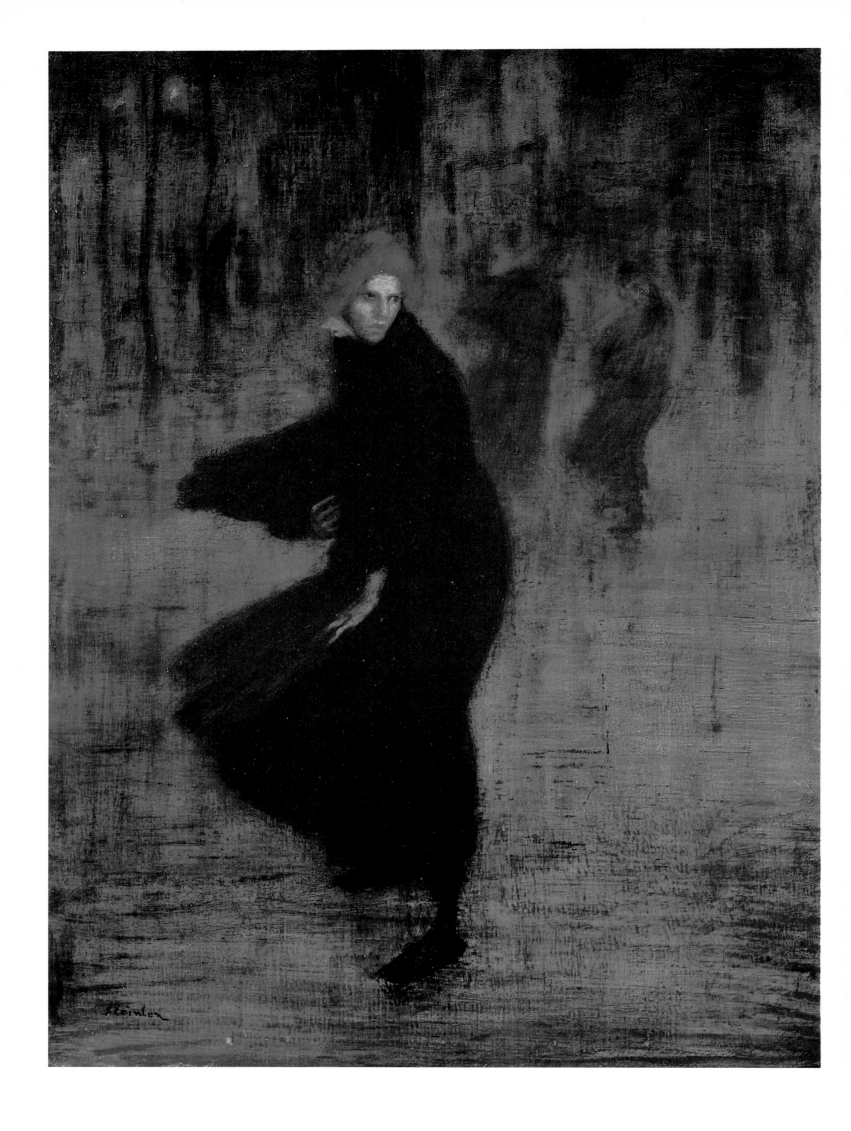

54

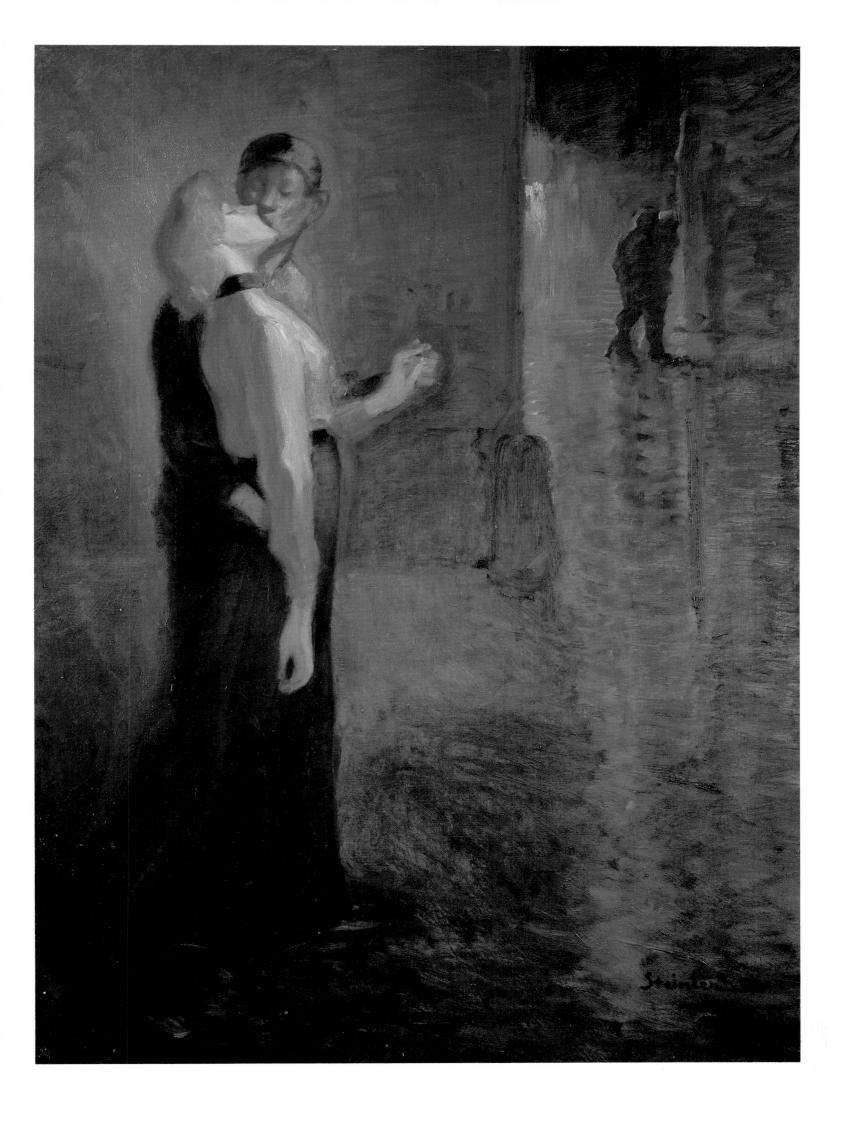

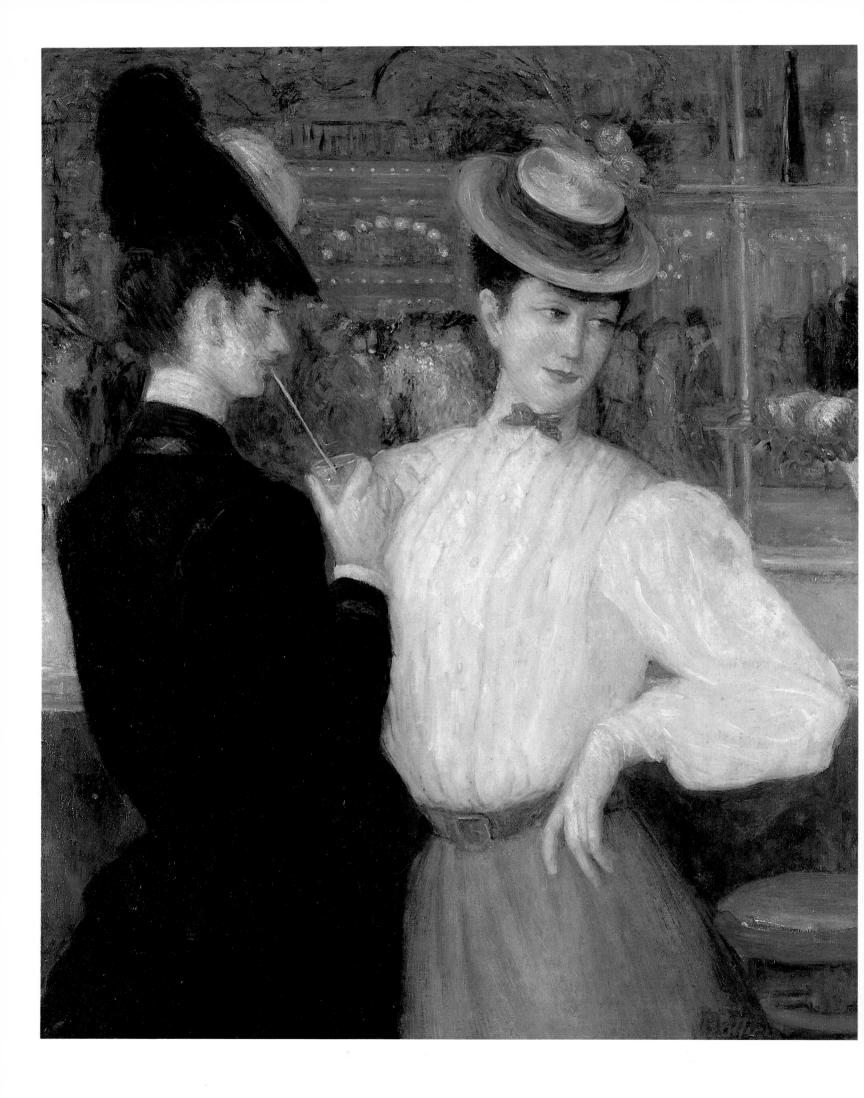

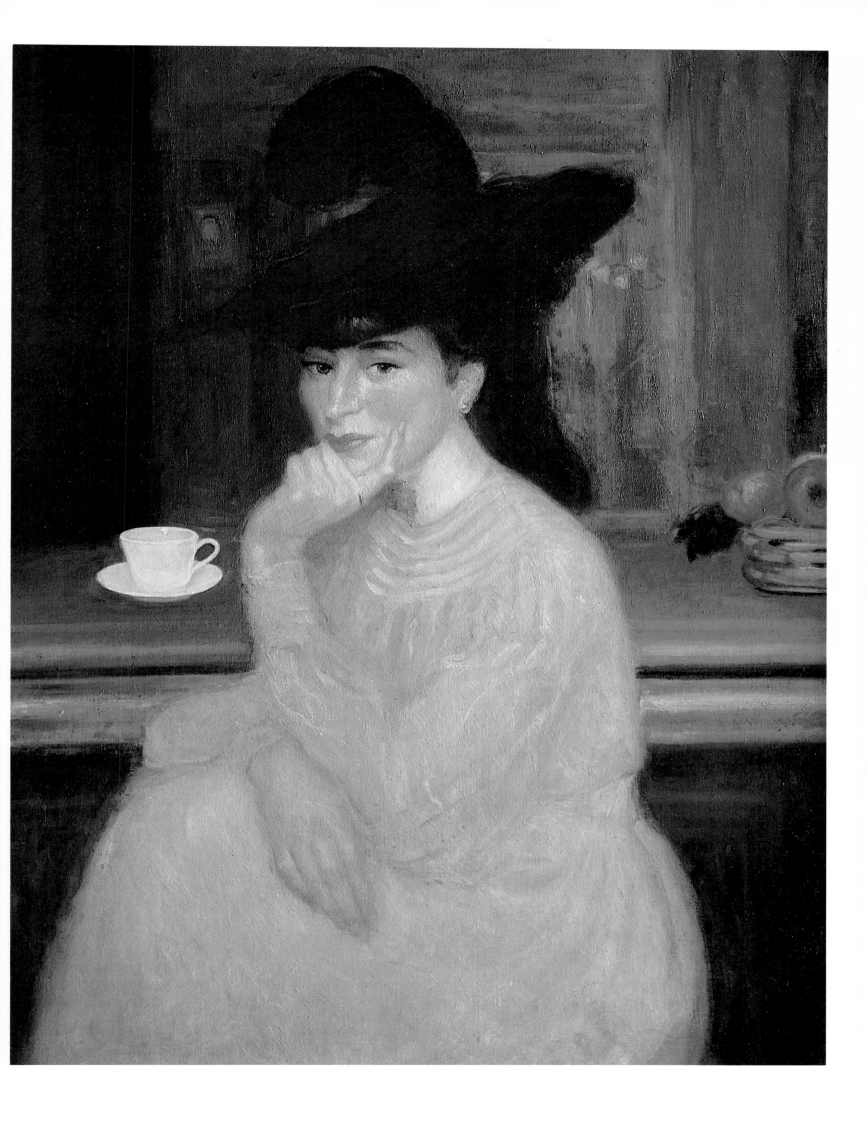

57

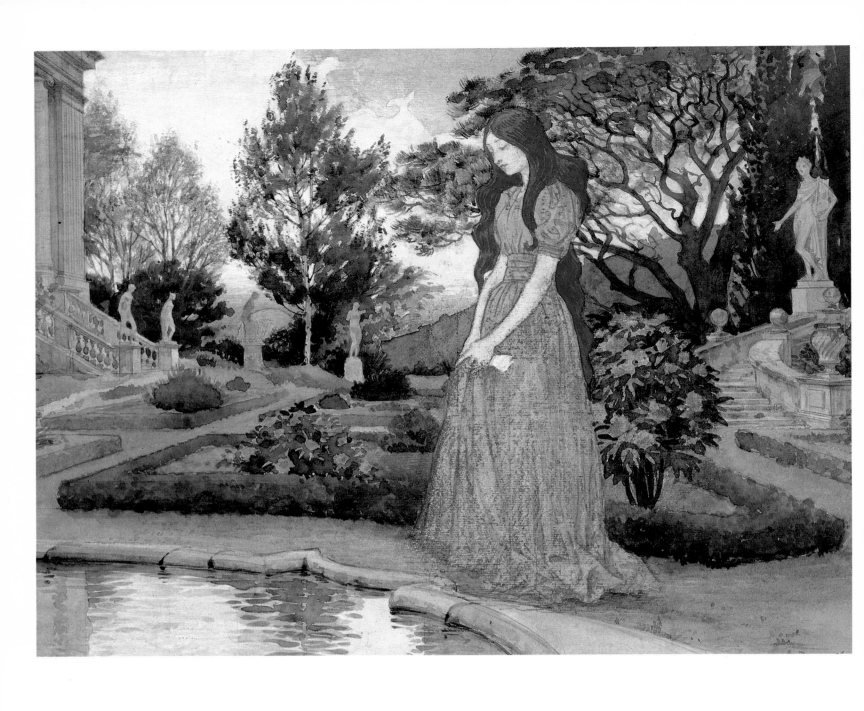

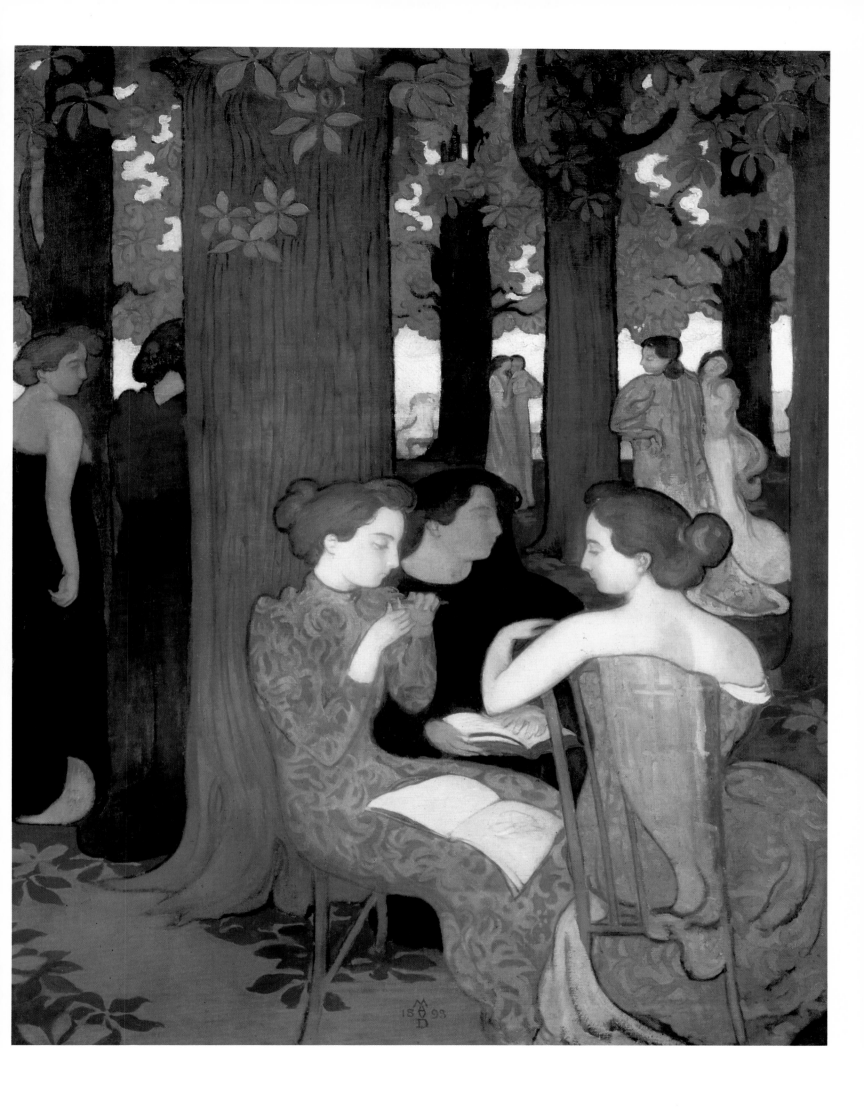

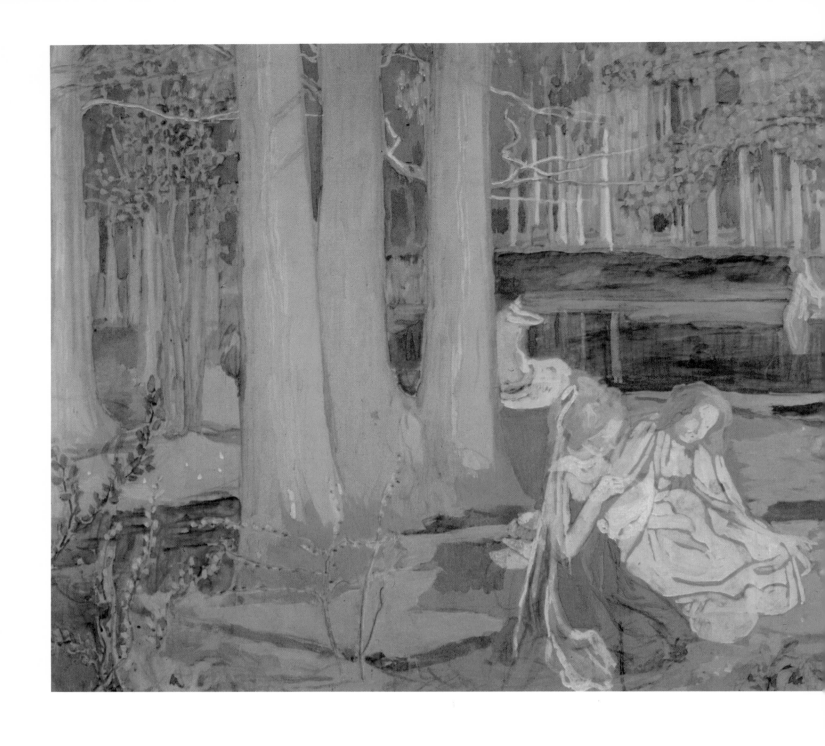

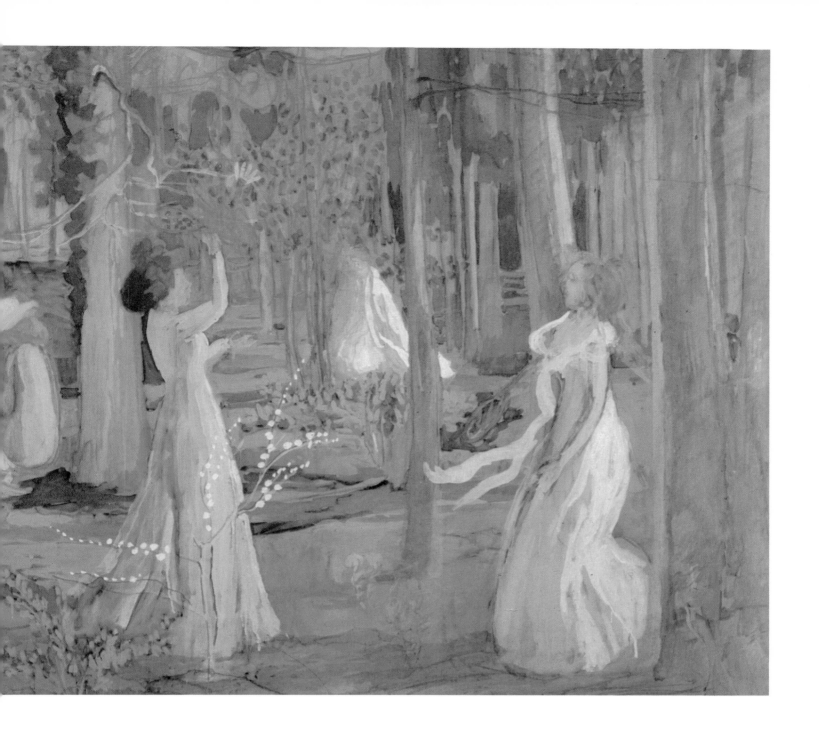

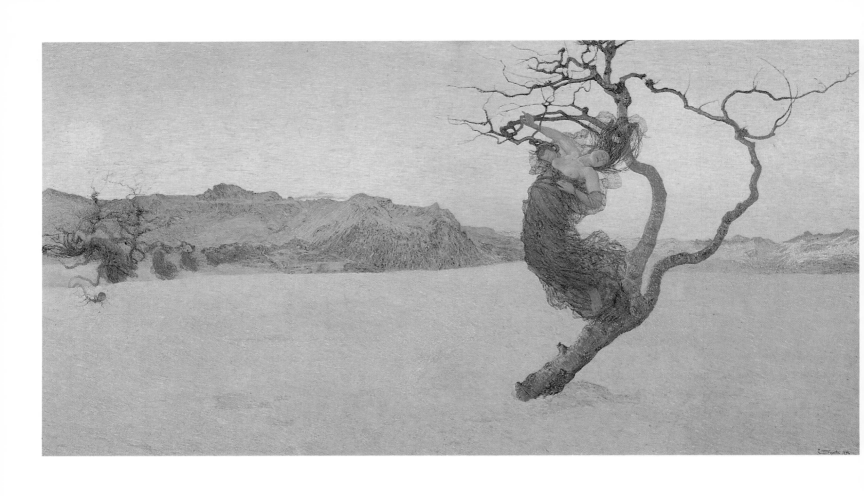

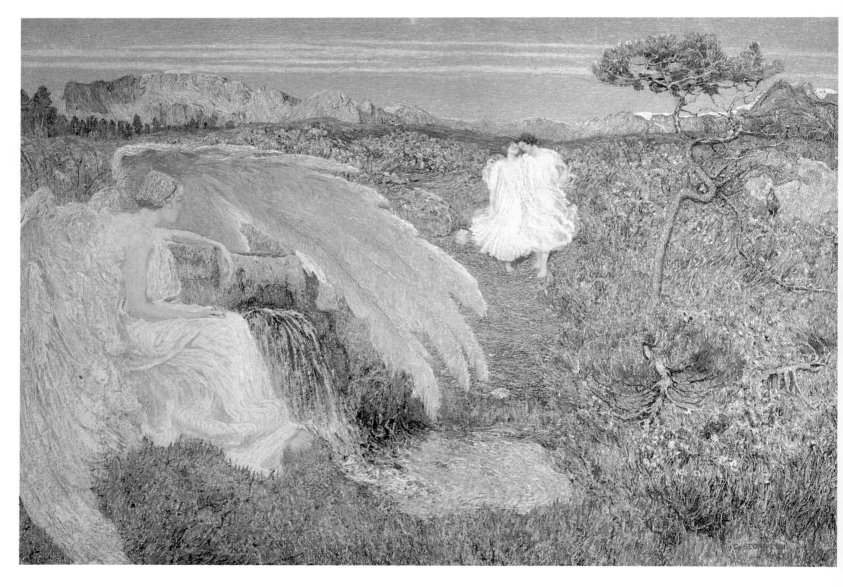

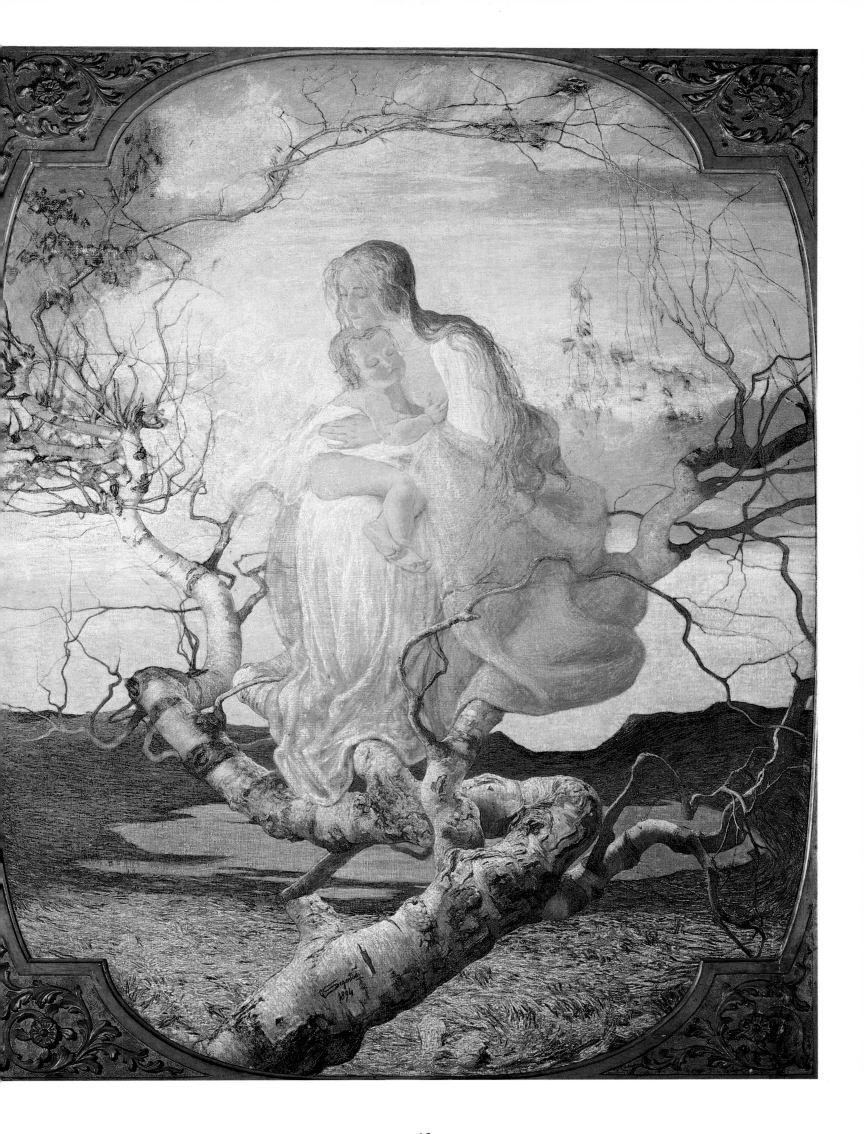

63

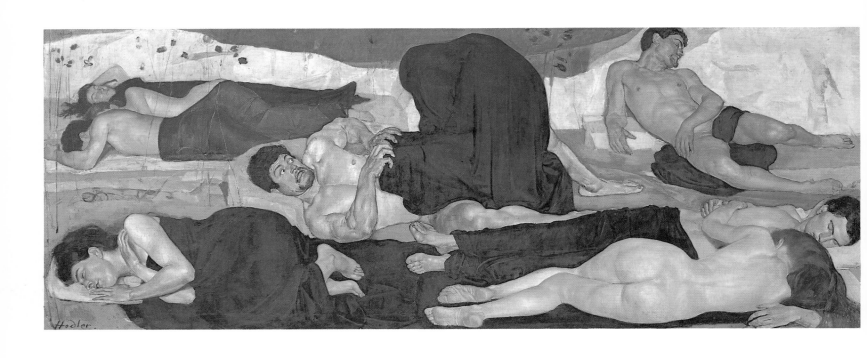

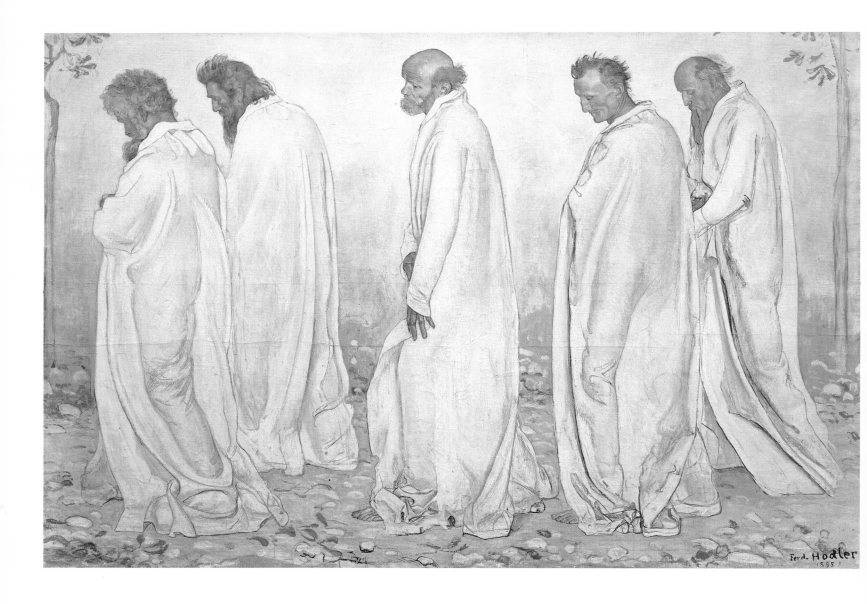

64

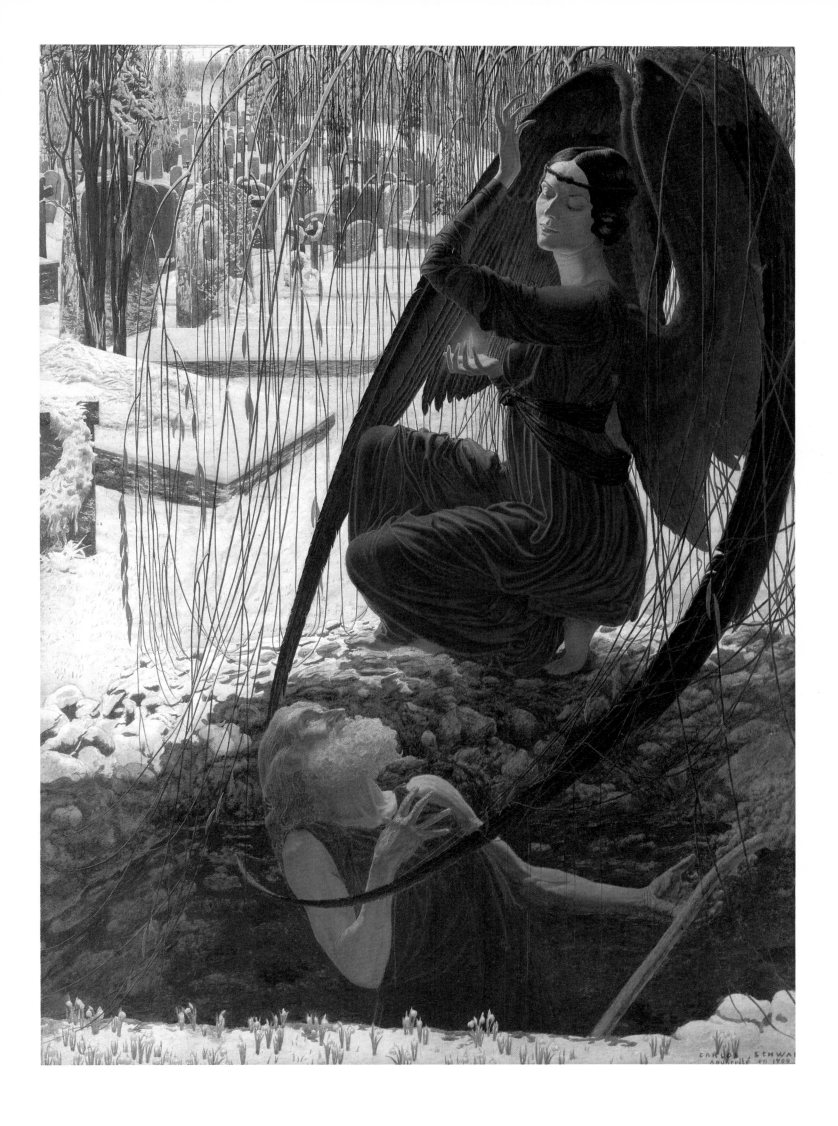

65

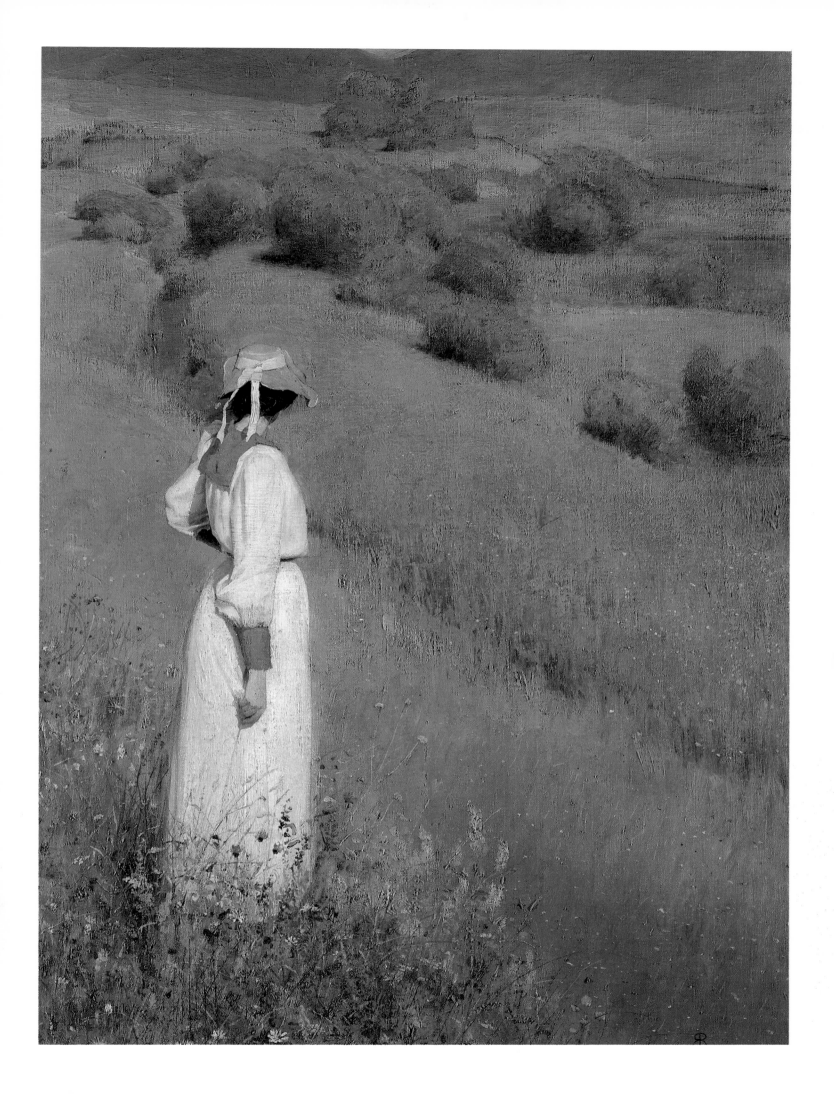

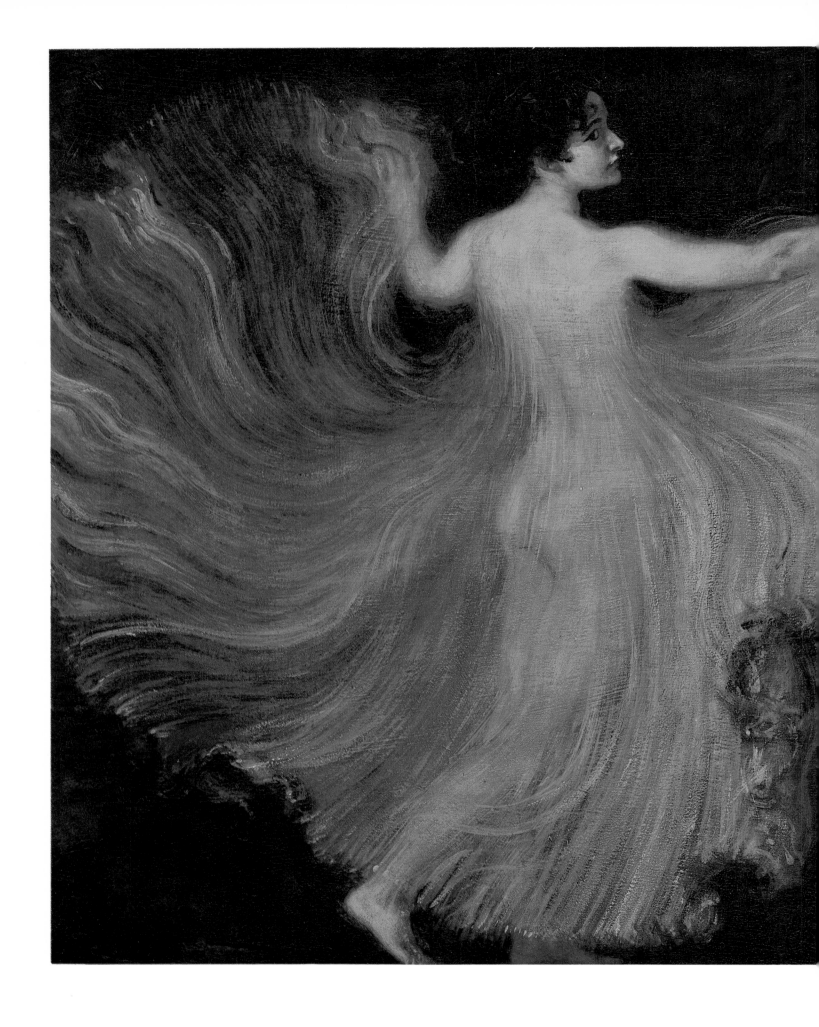

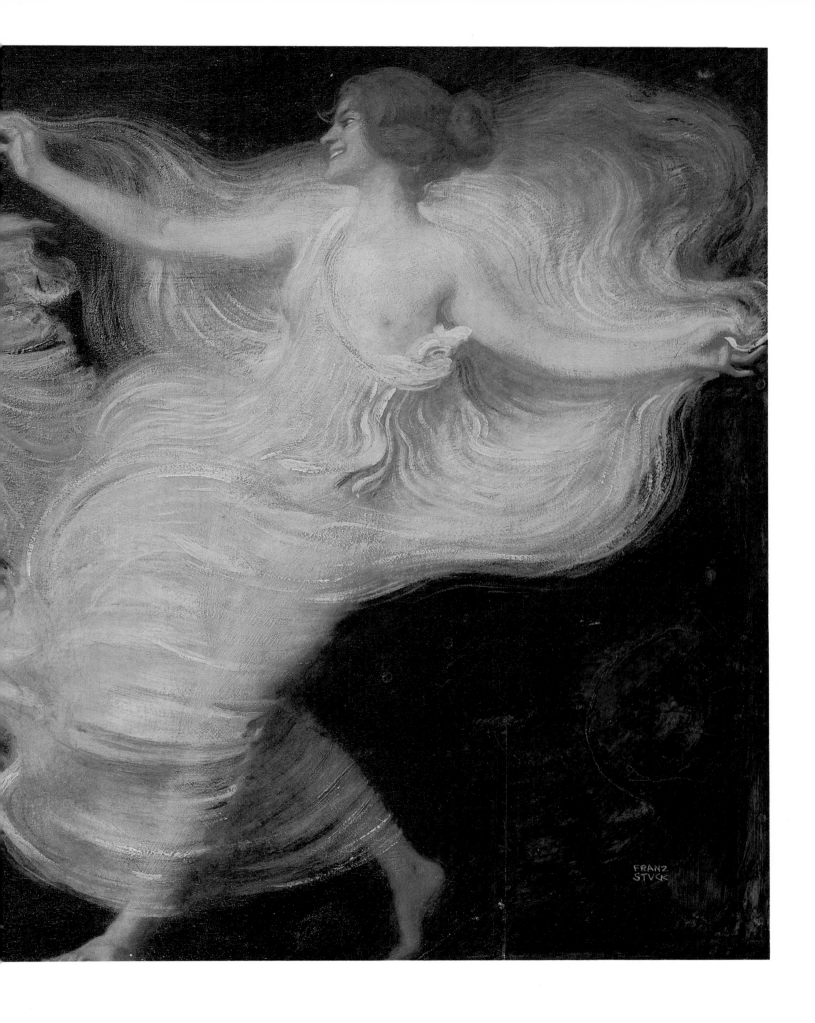

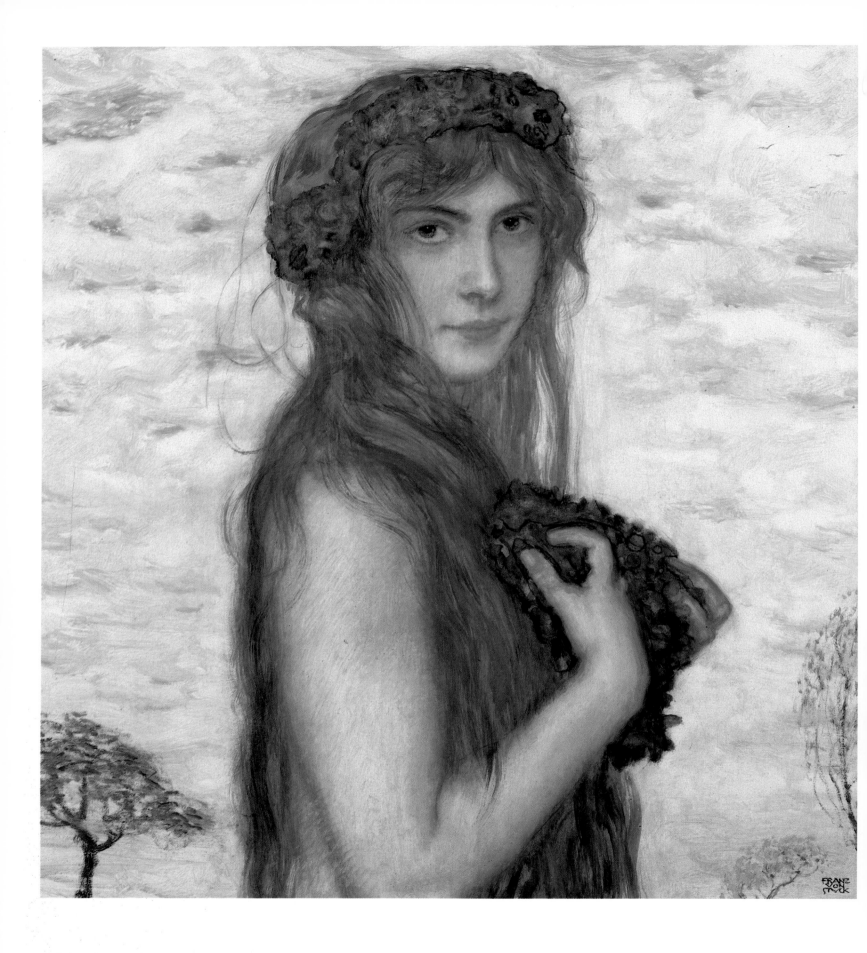

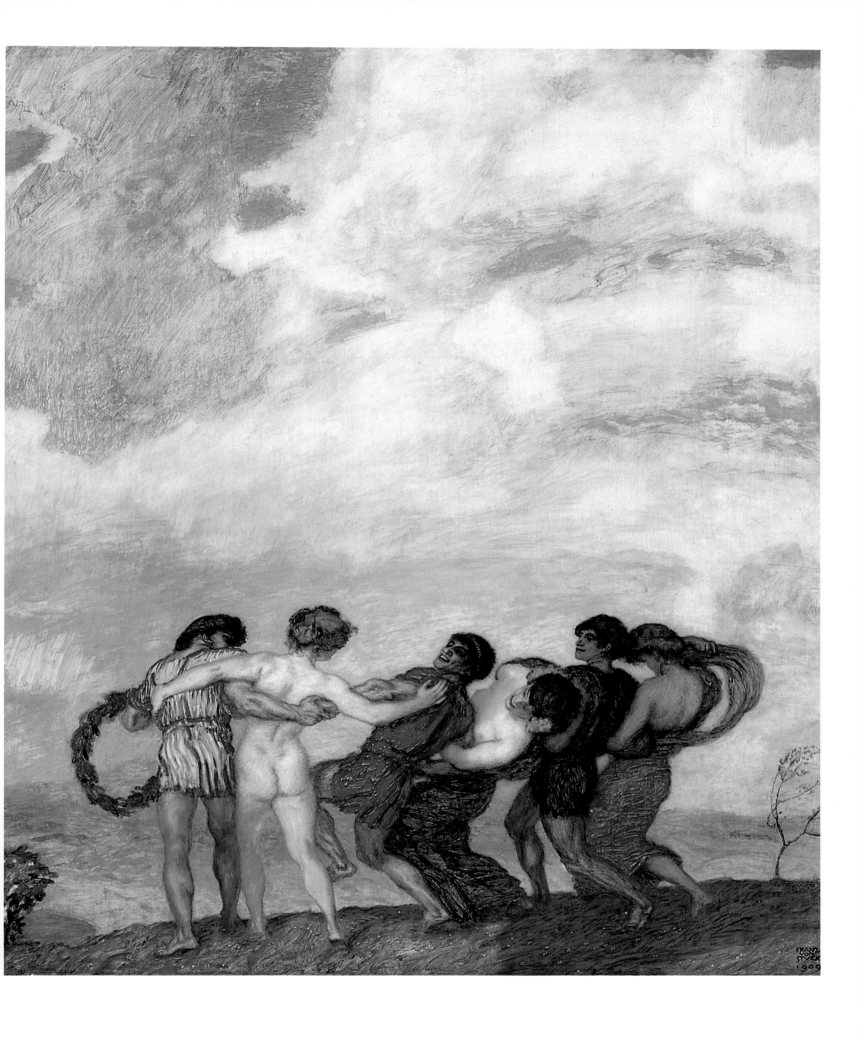

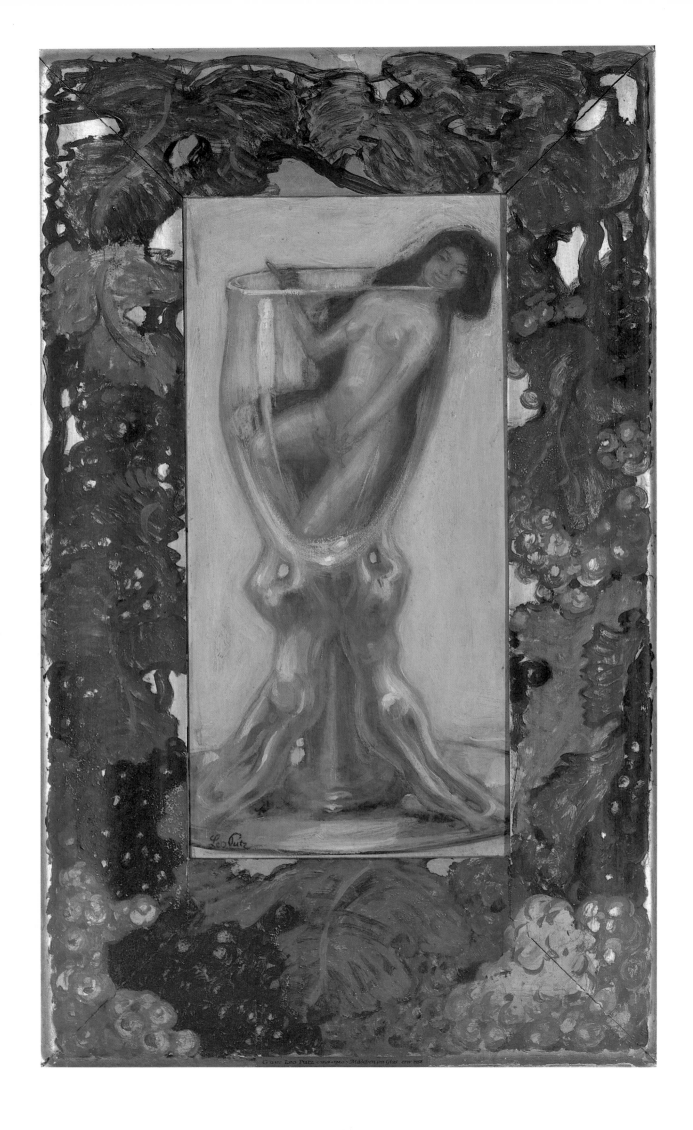

Graf Leo Putz (1869–1940) · Mädchen im Glas, etw. 1910

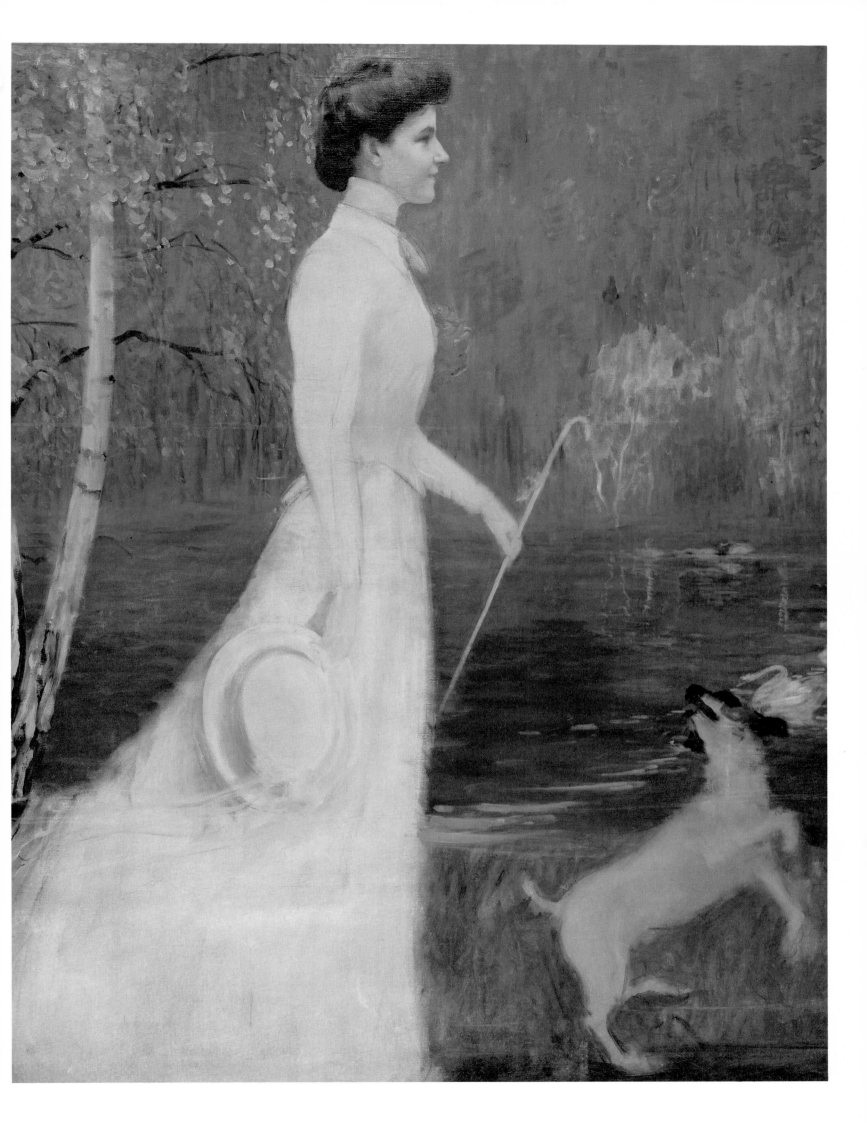

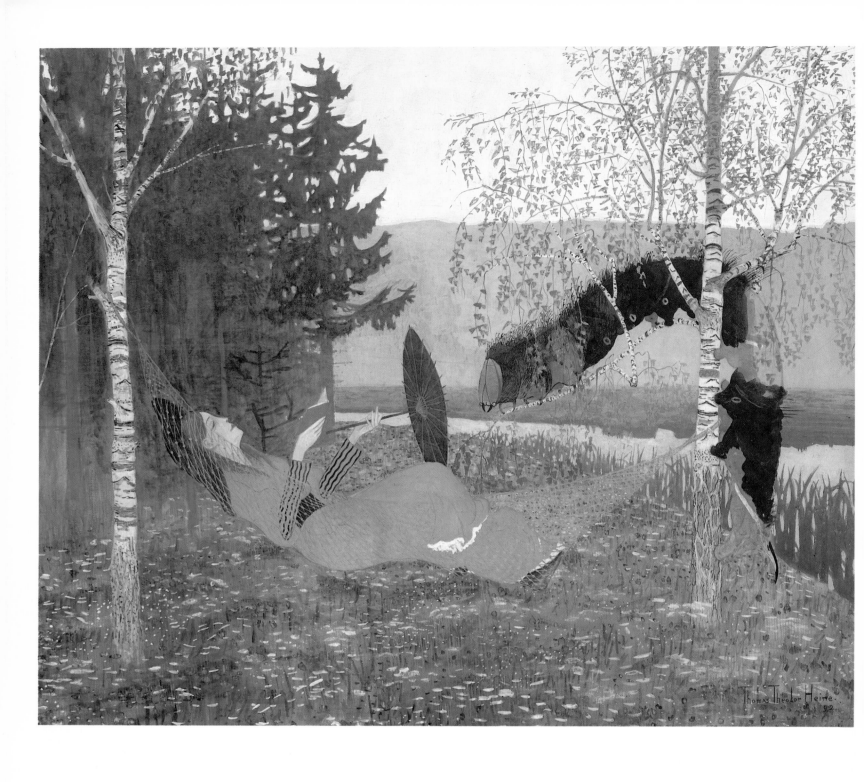

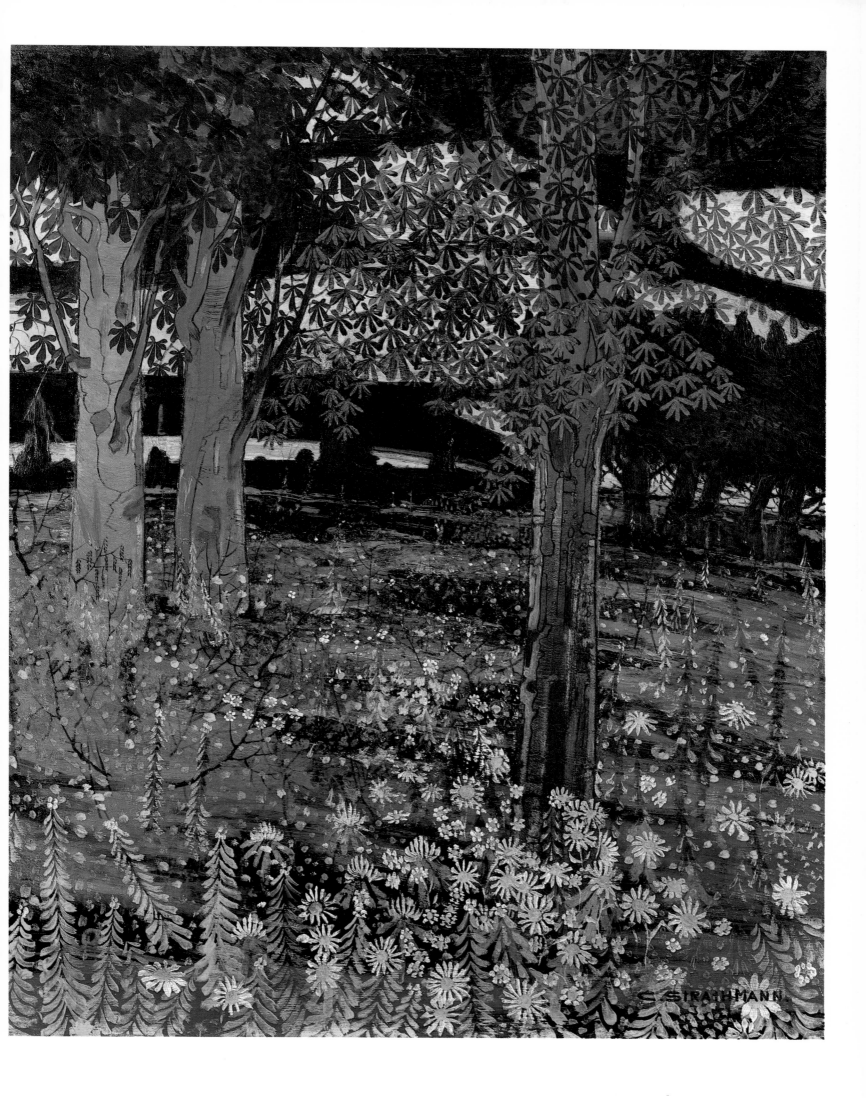

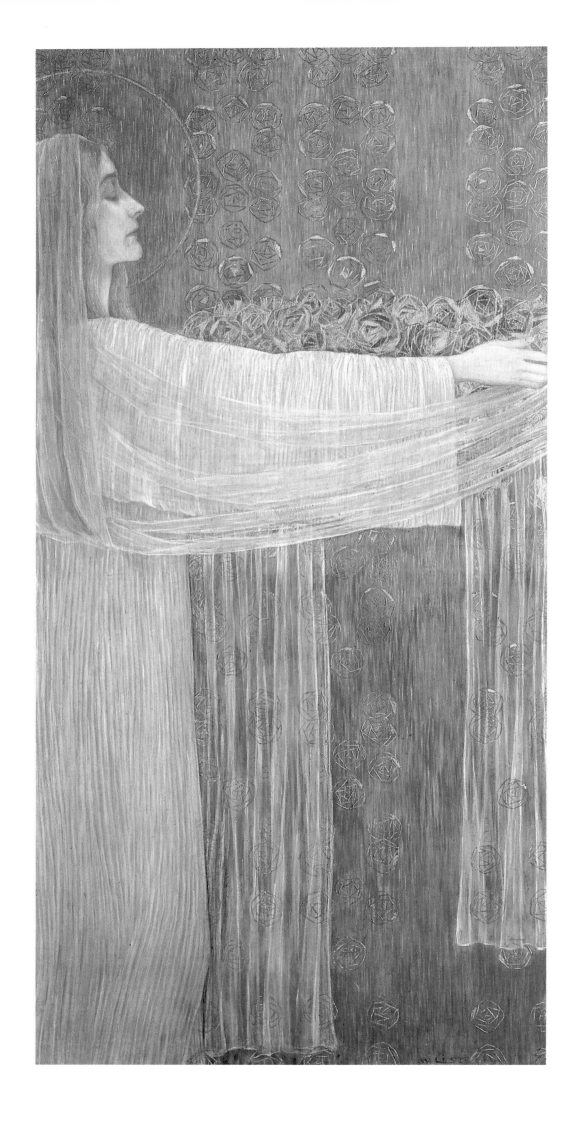

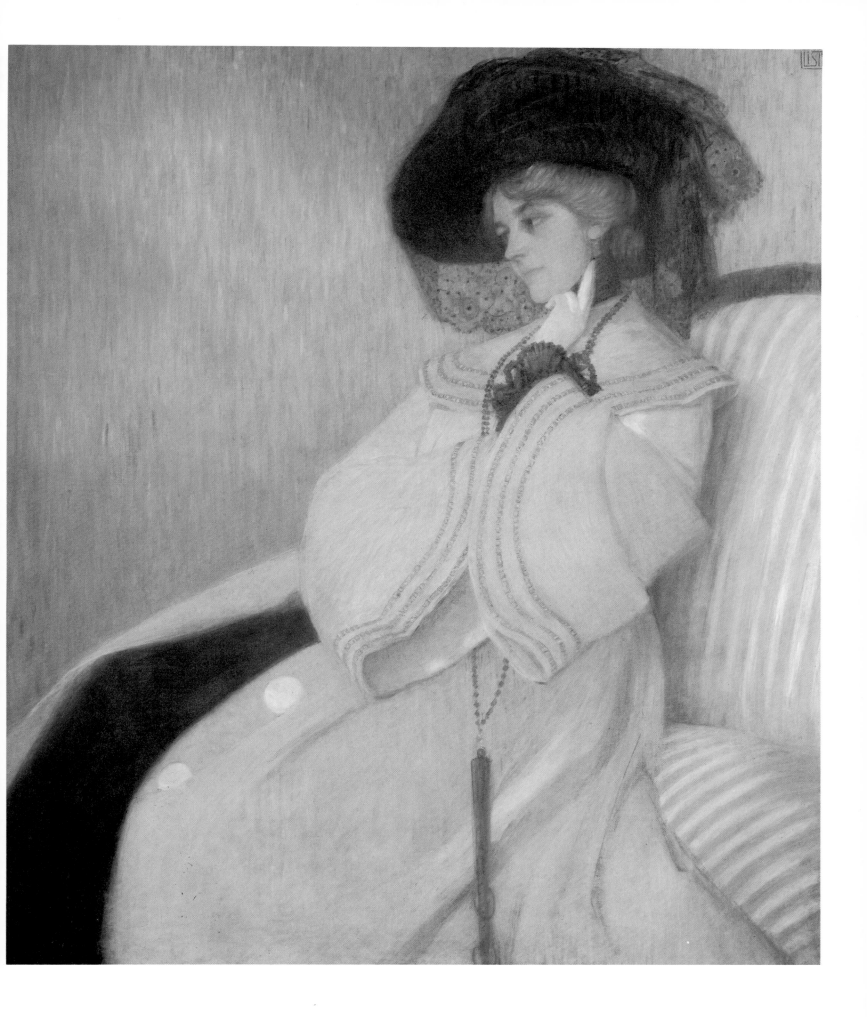

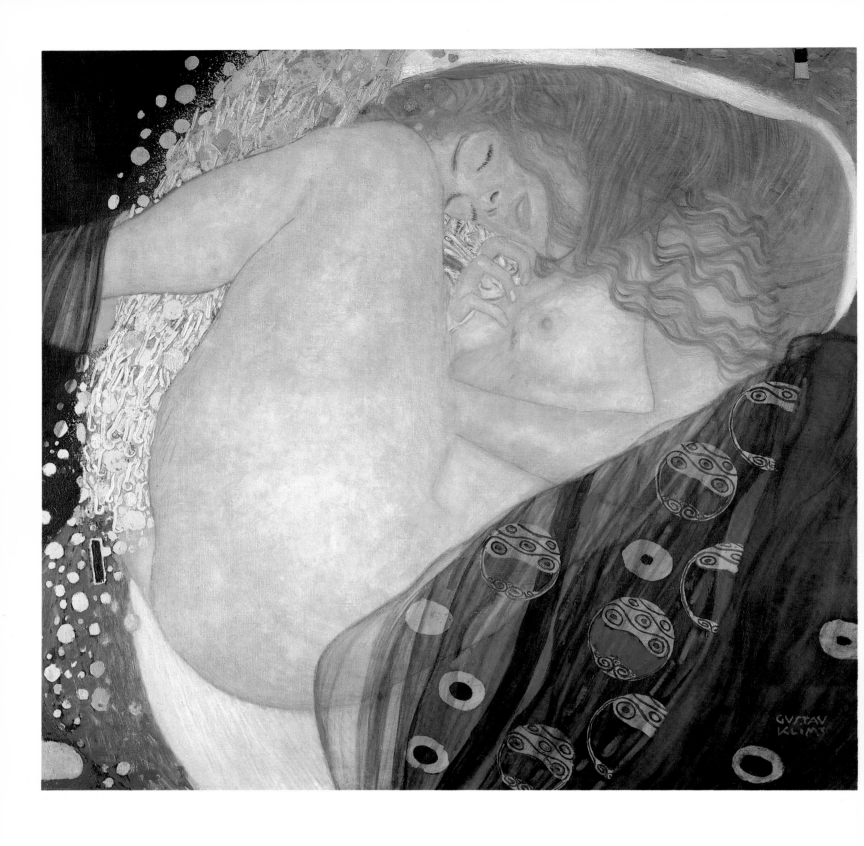

78

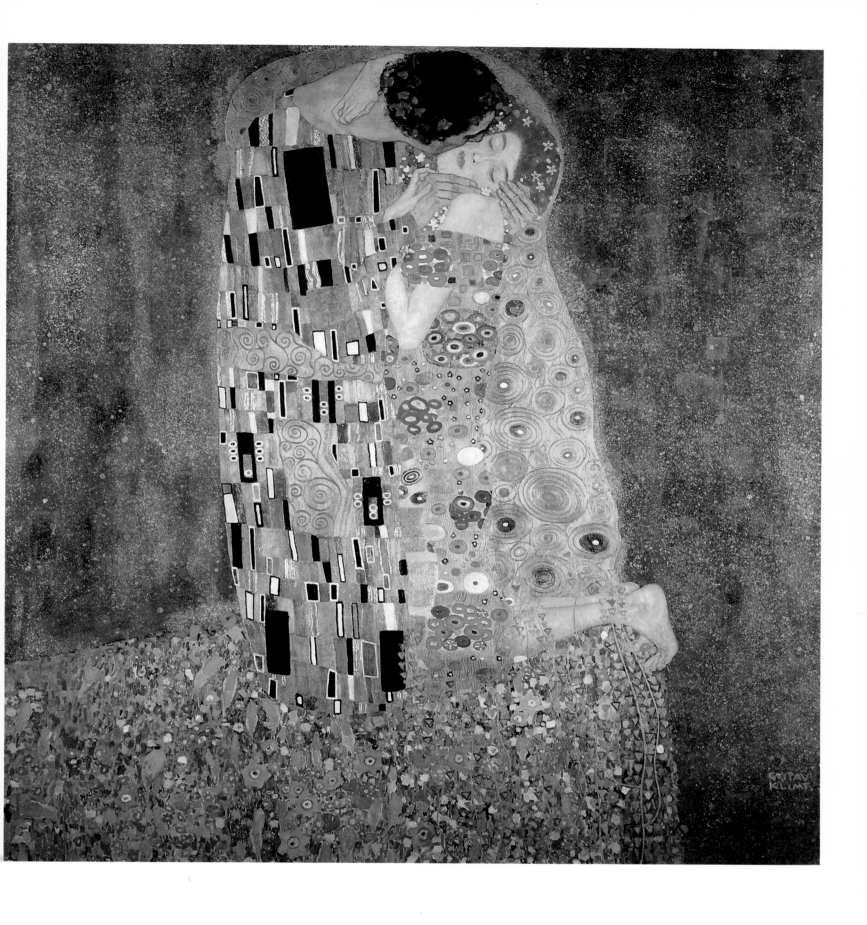

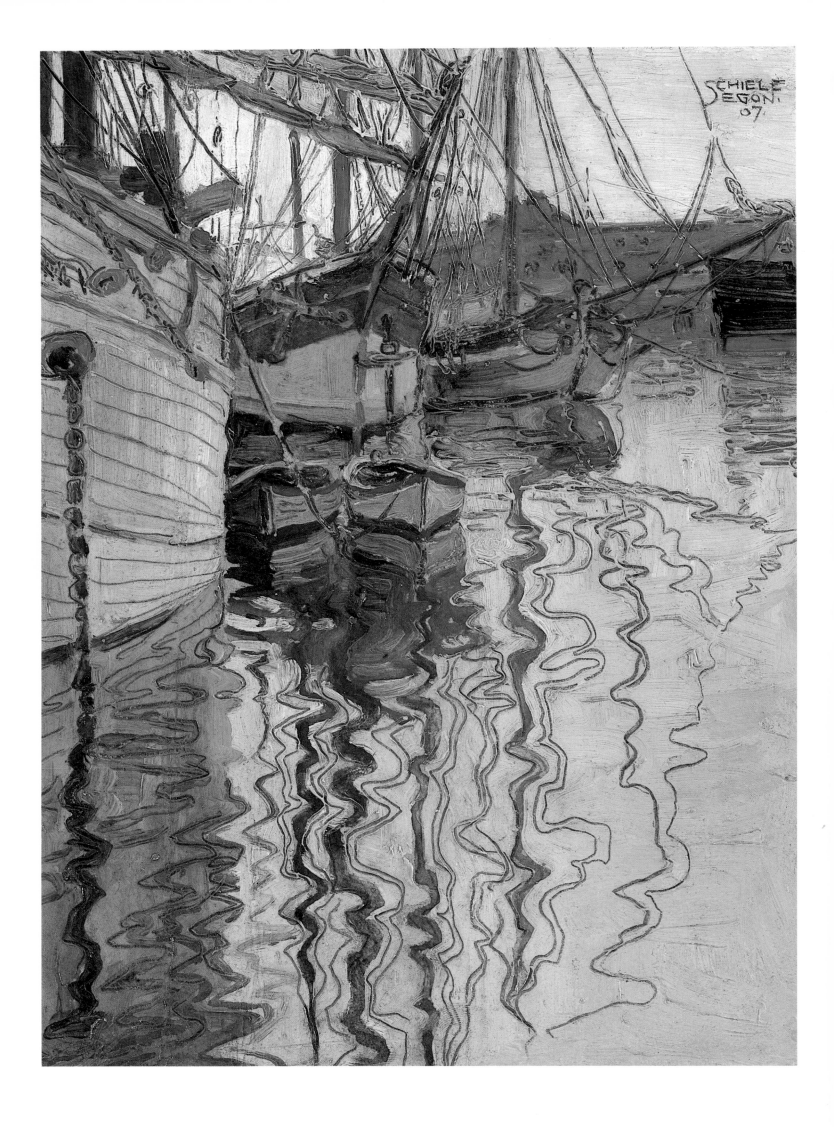

BIOGRAPHICAL NOTES

BÉRAUD, Jean

Petersburg 1849 - 1936 Paris

Béraud was a pupil of Léon Bonnet in Paris. He was a founder member of the *Société Nationale* and regularly exhibited with them from 1890-1929. Although he was actually a portrait painter like his tutor, he gained respect as a very exact observer and painter of contemporary social issues and as a chronicler of day to day life. In his later work he did not follow the general trends in the development of art but turned instead to religious themes which he transposed to modern times in a completely realistic style of painting. His exhibitions in the Salon evoked both fiery criticism and passionate approval.
Ill.p 52/53

BONNARD, Pierre

Fontenay-aux-Roses 1867 - 1947 Le Cannet

After completing his law studies Bonnard began a successful artistic career as a pupil of the *Académie Julian* and the *École des Beaux Arts* in Paris. He met Sérusier, Denis, Ranson and Vuillard, and together they founded the Nabis. His early works are full of decorative liveliness such as is found in Art Nouveau. In his graphic work there can be seen an extraordinary dynamism. His main works in this field were posters and lithographs for the journal *Revue Blanche*. Some of his motifs show influences gained from his friendship with Toulouse-Lautrec.
In his painting the sentiments of the Nabis can clearly be seen. On the whole Bonnard is counted among the main representatives of Post-Impressionism.
Ill.pp. 50,51

BOTTINI, George

Paris 1874 - 1907 Villejuif

Bottini, the son of Italian parents, grew up in France where he received his first artistic training in Studio Cormon. There he made his

first decisive contacts to the young avant-garde artists. He worked as a restorer of paintings for some years and this work helped him gain technical perfection as a painter.

Like Toulouse-Lautrec, Bottini also found his themes in the Parisian demi-monde and on the city's streets. The dancehalls, bars, variety theatres and brothels were the world of his paintings.

He became incurably ill while still a young man and only had a few active years as an artist. He died, mentally deranged, at the age of 31.

Ill.pp. 56, 57

BURNE-JONES, Sir Edward

Birmingham 1833 - 1898 London

Burne-Jones was a talented draughtsman from an early age. He was destined for the Church but a meeting with John Ruskin drew his attention to the art of the Pre-Raphaelites. He decided to abandon his divinity studies and to dedicate himself to an artistic career. He became a pupil of the Anglo-Italian D.G. Rosetti. During two trips to Italy he got to know the works of the Florentine masters. This had an effect on his work which was dedicated mainly to water-colours at that time. In the graphic field, he later became an excellent illustrator of books. The combination of Pre-Raphaelite art and Art Nouveau which was unique to Burne-Jones soon had an effect on Art Nouveau artists in Germany and Austria.

Ill.p. 38

CHRISTIANSEN, Hans

Flensburg 1866 - 1945 Wiesbaden

Christiansen is one of the most important artists of German Art Nouveau. He was a painter and graphic artist, and with his elegant style and subtle fantasy he was a leading figure in the area of applied art. He studied at the College of Arts and Crafts in Munich from

1887 - 1888 and then worked as a scene painter in Hamburg. After a stay in Paris where he studied at the *Académie Julian* from 1896 - 1899 he became a member of the artists' colony in Darmstadt (1899 - 1902). As a graphic artist he worked in many different areas, for example he drew many vignettes and illustrations and published a portfolio entitled "New Bas-Reliefs". In 1911 he settled in Wiesbaden and, as well as carrying on his artistic career, he also published literary and philosophical papers.

Ill.Table I.

CRANE, Walter

Liverpool 1945 - 1915 London

The painter and illustrator who came from an artistic family was first trained by his father and then in the studio of the painter and woodcutter W.T. Linton. He was associated with William Morris in his work for the reform of decorative and applied art, especially book illustrations. His graphic work is strongly influenced by Japanese coloured prints which in their own way characterize the typical lineation of Art Nouveau. As a painter he admired the Italian masters of the quattrocento and was an enthusiastic follower of the Pre-Raphaelites. He brought Symbolism and the spiritual ideas of the Pre-Raphaelites into harmony with the graphic aesthetics of Art Nouveau.

Ill.pp. 35, 36/37

CZESCHKA, Carl Otto

Vienna 1878 - 1960 Hamburg

The painter and graphic artist Czeschka studied at the Viennese Academy of Art under C. Griepenkerl. In 1902 he was already teaching himself at the Viennese College of Arts and Crafts. In 1908 he was made professor at the College of Arts and Crafts in Hamburg where

his above-average abilities as a graphic artist were recognized.

In Vienna he was a member of the Klimt group and a co-founder of the *Wiener Werkstätten*. He had a very special characteristic of areal treatment in his sketches and book illustrations. Areas deliberately left empty contrasted with heavily ornamented small parts. He also used the effects of gold, something which was typical for Viennese Art Nouveau.

Ill.Table II.

DENIS, Maurice

Grandville 1870 - 1943 St.-Germain-en-Laye

Denis studied at the *Académie Julian* where he became a friend of Sérusier, Bernard, Bonnard and Ranson. Through them he came into contact with the *Nabis* whose theories immediately captured him. Denis, Bonnard and Vuillard rented a studio together in 1891. He worked a lot in the area of theatre decoration and in religious painting and was regarded as the theorist of the Nabis group. He was hardly influenced by the Impressionist School, instead his relationship with Redon and Gaugin was more style-forming for his art. Also the Symbolists and the Pre-Raphaelites with their training to sensitivity had decisive impulses on his work, which radiated harmony and a peace which was detached from everyday life. Subdued matching tones determined the harmony of his pictures in which characteristics of Art Nouveau painting can clearly be seen.

Ill.pp. 59, 60/61

ENGELHART, Josef

Vienna 1864 - 1941 Vienna

Engelhart received his training as a painter and sculptor at the Technical College in Vienna and at the Munich Academy. An important

event in his life was a stay in Paris in 1890 which was followed by study trips to Spain and Italy. The strong influence of the French Impressionists on his work remained, and undoubtedly resulted from contacts made during his time in Paris. Engelhart was a founder member of the *Viennese Sezession*. He became president after Gustav Klimt. He was especially involved in the exhibition activities of the group where he had a lot of influence and contributed greatly to the success of the exhibitions. He was a member of the *Hagenbund* (named after the coffee-house owner Hagen whose café *Zum Blauen Freihaus* was a meeting place for the group of artists).

Ill.Frontispiece

EVENEPOEL, Henri Jacques Edouard

Nice 1872 - 1899 Paris

The Belgian painter and graphic artist studied at the *Académie des Beaux Arts* in Brussels and after that became a pupil in Gustave Moreau's studio where he met Matisse and Rouault. He quickly left behind the dark tones of the academical style and painted portraits and milieu studies of Parisian life in which a clear influence of Art Nouveau can be seen. His promising artistic career was limited to just six years. He died of typhoid fever in 1899.

Ill.p. 46

FORAIN, Jean-Louis

Reims 1852 - 1932 Paris

Forain was a graduate of the *École des Beaux Arts* in Paris. For a short time he turned to history painting, but soon belonged to the first Impressionist circle where he was the youngest artist. He experimented under the influence of Art Nouveau, but only for a few oil paint-

ings and in his drawing work. Edgar Degas who was also a good friend had an influence on his painting. A number of paintings with sociocritical content brought him a certain degree of renown, mainly because these works had a strongly erotic slant. He was very close to Toulouse-Lautrec and Daumier in this area of his work. Without doubt Forain's main significance is in the field of printing and drawing. He created perfect etchings and lithographs and worked for newspapers as a caricaturist.

Ill.p. 47

GRASSET, Eugéne

Lausanne 1841 - 1917 Sceaux

Grasset first studied architecture. In 1917 he moved to Paris where he dedicated himself to an artistic training. The Japanese woodcuts, which in those days were very modern, had a strong influence on Grasset. He was very talented in many areas, including applied art. He designed stained glass windows and mosaics as well as carpets and fabrics. But his main abilities were in the field of graphic art, especially printing. He developed a special technique which was a mixture of lithography and woodcut with which he was very successful. With his specific elaboration of plants with arabesque-type interlacement, he became an inspiration for Art Nouveau and its great artists.

Ill.p. 58

HEINE, Thomas Theodor

Leipzig 1867 - 1948 Stockholm

The German draughtsman, painter and author was a student at the Düsseldorf Academy. After working in Munich and Diessen in Upper Bavaria he emigrated to Prague in 1933, then to Brünn and Oslo and lived in Stockholm from 1942. As a graphic artist he occupied himself a lot with book illustrations and book ornamentation. In

1896 he founded the satirical illustrated weekly magazine *Simplizissi-mus* together with Albert Langen. E. Thöny and O. Gulbransson al-so contributed to the magazine. Even in his oil paintings can be seen an artist who was critical of contemporary issues. He played a major role in the Munich Art Nouveau scene.

Ill.p. 74

HODLER, Ferdinand

Berne 1853 - 1918 Geneva

Hodler had a deprived childhood and at the age of fourteen began an apprenticeship as a scene painter. In 1871, he began his studies at the *École des Beaux Arts* in Geneva. He settled in Geneva and apart from a few short trips never left it again. A friendship with the Symbolist poet L. Duchosal was decisive for his art which was deeply rooted in Naturalism. Symbolism gave his naturalistic-realistic paintings new content and moved him to develop his own theories of parallelism. From then on his pictures were characterized by symmetry, move-ment was expressed less by the figures than by the repetition of parallel forms which were meant to express superior laws. A major part of Hodler's oeuvre is assigned to Art Nouveau.

Ill.pp. 64 top, 64 bottom

KHNOPFF, Fernand

Grembergen-Lez-Termonde 1858 - 1921 Brussels

After leaving the faculty of law, Khnopff entered the art academy in Brussels where he became a pupil of Xavier Mellery. During a stay in Paris he got to know Gustave Moreau's work and was excited by it. Moreau's influence and impulses from the Pre-Raphaelites were embodied in Khnopff's mystical-allegorical paintings which are numbered among works of early Art Nouveau. In 1883 he belonged to the founder members of the Brussels group *Vingt*, although he

mainly exhibited in Paris. He was involved with the Symbolist circle, allowed their ideas to flow into his work and eventually became the main representative of Belgian Symbolism. Khnopff introduced multifarious philosophical and esoteric-visionary influences into art. His creations were based on the works of the authors Emile Verhaeven and Maurice Materlinck. His tendency to stylization, his sublime, almost morbid expression of colour and his female figures, which almost always combine sensuality with coolness, had a great influence on Art Nouveau painting in Vienna and Munich.

Ill.pp. 39 top, 39 bottom

KLIMT, Gustav

Baumgarten 1862 - 1918 Vienna

Klimt studied at the Vienna School of Applied Art and became famous with his decorative murals in the grandiose tradition of Makart. He gained world fame as one of the great artists of the style of Art Nouveau which was only found in Vienna. His encounter with the mosaics in Ravenna made such an impression on him that he created formal paintings in gold, often with erotic themes.
His work developed logically towards Expressionism which he anticipated in his last paintings.

Ill.pp. 78, 79

KÖNIG, Friedrich

Vienna 1857 - 1941 Vienna

König studied at the School of Applied Art of the Austrian Museum in Vienna. He was a founder member of the *Viennese Sezession* and a member of the editorial staff of *Ver Sacrum*. He belonged to the artists of the Hagenbund, together with Rolf Bacher, Adolf Böhm, Alfred Roller and Josef Engelhart. One of the most important large commissions was the decoration of the Friedmann villa in Hinter-

brühl near Vienna which had been built by Joseph Maria Olbrich. König also created many wood engravings for book illustrations.

Ill. table III

KRØYER, Peter Severin

Stavanger 1851 - 1909 Skagen

The budding painter studied from 1864 till 1870 at the Copenhagen Academy. He then worked in Bonnat's studio in Paris. Krøyer joined the northern artists' colony in Skagen in 1882 where he had a considerable influence.

Group portraits, presented informally, were his favourite choice of theme. A special mention should be made of his ability to realize momentary light effects, subtly perceived, in his pictures, in his landscapes as well as in his rooms flooded in light or lit by candle. For the northern artists as for many artists of the time, the approximation to Art Nouveau was only a transition stage.

Ill.p. 41 top

LACOMBE, Georges

Versailles 1868 - 1916 Alençon

Lacombe came from a well-to-do French family and his liking and talent for drawing and painting was recognized and encouraged by his mother early in his life. He attended the Studio Roll in Paris and after that the *Académie Julian*. From 1888 till 1897 he regularly spent the summer months in Brittany among artist friends. After he had got to know Paul Sérusier in 1892, he also took part in the exhibitions organized by the *Nabis*. As with many other artists from his circle the style-forming influence of the Breton landscape can also be seen in his work which also links him with Gauguin's work, especially the wood-carvings. Lacombe occasionally gave his Symbolist influenced picture motifs an Art Nouveau type of lineation and arrangement.

Ill.p. 44

LARSSON, Carl

Stockholm 1853 - 1919 Lundborn

He was one of the young Swedish painters who revolted against the backwardness of the Stockholm Academy. In 1877-78 he went to Paris for the first time and from then on was under the influence of the *École de Paris*. In 1880 he settled in Paris and in the following years followed the Impressionists. In 1885 he returned to Sweden and from 1886-1888 and then again from 1891-93 he taught at the Valand art school in Göteborg. Larsson's style is deeply rooted in the Swedish tradition, however, it is imbued with Impressionism, Japanese art and Art Nouveau. From 1890 Larsson's extraordinarily charming watercolours and drawings had formed the typical "Larsson Style". With his six frescoes in the National-museum in Stockholm he became the founder of modern Swedish monumental painting.

Ill.p. 41 bottom

LIST, Wilhelm

Vienna 1864 - 1918 Vienna

The son of a Viennese municipal architect studied under Professor Griepenkerl in Vienna, the tutor who trained many of the young Viennese artists. Later he studied under Löfftz in Munich and at the Academy in Paris under A. Bougereau. When he returned to Vienna, List exhibited in the Künstlerhaus from 1893 and joined the *Sezession* in the year of its foundation, 1898. From 1900 he worked with the editorial staff of the journal *Ver Sacrum* which can thank him for many contributions. In 1905 the Klimt group, to which List belonged, left the *Sezession*. He was represented at both the art shows in 1908 and 1909. However, the largest public commission was the execution of the paintings in the conference room of Otto Wagner's Post Office building.

List was a very modest and unassuming artist, his work has only been properly honoured in the last few years.

Ill.pp. 76, 77

MUNCH, Edvard

Løeten near Hamar 1863 - 1944 Ekely near Oslo

Munch's exceptionally difficult and deprived childhood and youth had an effect on the seriousness of his work. His oeuvre is Scandinavia's greatest contribution to modern art. Like van Gogh he was ahead of his time, as he developed Naturalism further into Expressionism. In this way, during many journeys to Paris and Berlin, there were naturally fruitful contacts with the Impressionists. Through the circle around the *Nabis* he came into contact with Symbolism with typical Art Nouveau characteristics. Because of his great graphic works, his oeuvre became one of the main foundations of the development of western art in the 20th century.

Ill.pp. 42 top, 42 bottom, 43

OLDE, Hans

Süderau/Holstein 1855 - 1917 Kassel

Hans Olde grew up on a large estate in Holstein. After an apprenticeship in agriculture he was allowed to begin his long-desired art studies in Munich where he became a pupil of Ludwig von Löfftz. A study trip to Paris was crowned by several months work at the *Académie Julian* where he worked with Corinth.
After this he moved back and forward between Munich, where he joined the secessionist movement, and Paris, where Monet's paintings made a great impression on him. He received commissions from Hamburg, Berlin and Weimar and was eventually made director of the Weimar Art School in 1902. Here, working together with Henry van de Velde and Harry Graf Kessler posed him new and exciting problems. In 1911 he followed the invitation to the Art Academy in Kassel where he was also made director.

Ill.p. 73

PUTZ, Leo

Meran 1869 - 1940 Meran

Leo Putz came from South Tyrol. Although he always remained attached to his hometown of Meran, he found his sphere of work and life in Munich where he became a significant member of the *Jugend* circle. After a training at the Munich Academy where, like many of his contemporaries, he was a pupil of Hackl, he was accepted in the *Académie Julian* during an extended study trip to Paris. When he returned to Munich he joined the *Scholle*, painted in the artists' colony in Dachau and soon became a popular worker for the *Jugend* which published numerous contributions and title-page pictures from Putz. Adolf Hölzel was a lifelong friend who gave him inspiration for many of his later works. Putz was very successful in his younger years. A great deal of this success was due to the Munich art dealers Brakl and Thannhauser who specifically supported him. To be exhibited in that renowned gallery meant in those days to belong to the leading artists of the city of Munich.

Ill.p. 72

RANSON, Paul

Limoges 1861 - 1909 Paris

Ranson was a French painter and craftsman who studied at the *Académie Julian* in Paris. He grew up and was educated with the privileges of the upper middle-classes and developed a free and easy-going lifestyle. His studio in Paris became the "temple" of the *Nabis* where great emphasis was placed on sociableness.
Ranson was influenced by Gauguin, joined the Symbolists, and in 1908 he founded his own art school in which he himself taught. After his death, his wife ran the school. His friends Denis, Bonnard, Sérusier, van Rysselberghe, Maillol and Vallotton all gave lessons at the school.
In Ranson's work, in its decorative lineation, in the spirit of Art Nouveau, the influence of Oriental cultures can clearly be recognized.

Ill.p. 45

RIEMERSCHMID, Richard

Munich 1868 - 1957 Munich

The son from a respected Munich industrialist's family studied at the Munich Academy of Art under G. von Hackl and L. von Löfftz. His inclinations were for painting, but his lifelong work was much more strongly orientated to architecture, interior decoration and applied art. Especially his ideas of the garden city were path-breaking for urban development in Germany. The theatre in Munich, built in 1900, numerous designs for furniture and interiors for the great exhibitions (including the gold medal for his "room for an art lover" at the World Exhibition in Paris in 1900), the planning of Hellerau near Dresden and, often mentioned in the media, the emperor's suite for the passenger ship "Kronprinzessin Cecilie" are just a small selection of the many designs which the artist accomplished. It is therefore not surprising that his painting which was a match for other artists at the time, has been forced to the background in the consideration of his life's work.

Ill.pp. 66, 67

RYSSELBERGHE, Theo van

Gent 1862 - 1926 Saint-Clair

The leading Belgian exponent of Neo-Impressionism and Pointillism studied under Canneel at the *Académie des Beaux Arts* in Gent and from 1881 at the Academy of Brussels. In 1883, he was a founder member of the *Cercle des XX*. Friendships with the Parisian painters, expecially Denis, Seurat and Signac, were decisive for his artistic career. He exhibited with them in the *Salon des Indépendants*. Art Nouveau and his contact to the leading art centres is mainly obvious in his graphic work. His picture of Irma Séthe playing a violin was reproduced in the Viennese Art Nouveau magazine *Ver Sacrum*.

Ill.p. 40

SCHIELE, Egon

Tulln 1890 - 1918 Vienna

After his training at the Academy in Vienna the contact with Klimt became decisive for his further work. Obviously inspired by Klimt in theme and form canon, he soon developed his own individual characteristics and colour. Shortly before his early death, an exhibition in the *Sezession* brought him the first major recognition.

Ill.p. 80

SCHWABE, Carlos

Altona 1866 - 1929 Avon

A Swiss painter and graphic artist of German origin. After his studies at the *École des Beaux Arts* in Geneva he settled in Paris in 1890 and later in Barbizon. He exhibited in the *Salon de Société Nationale des Beaux Arts* and in the *Salon de la Rose et Croix* from 1891. As an Art Nouveau painter he was strongly influenced by Mucha. He showed an extraordinary precise drawing style in his watercolours and numerous book illustrations. But his ties to the Pre-Raphaelites and Symbolists can be especially seen in the choice of his motifs and their design.

Ill.p. 65

SEGANTINI, Giovanni

Arco (Trento) 1858 - 1899 Pontresina (Oberengadin)

Only a few artists succeeded, in spite of turning to revolutionary new aims, in finding recognition, also from an economic point of view. Segantini was one of the exceptions. Early contacts to a capable art dealer in Milan soon brought the very talented artist interna-

tional fame. He became the main representative of Post-Impressionism in Italy, he was a Pointillist and an important Symbolist.
He developed his own technique of splitting up colour with which he was especially able to express the clear air of the mountain world. His later works are strongly permeated with symbolistic ideas, where certain decorative elements in the composition and lining show a connection to Art Nouveau tendencies. Segantini became a member of the Viennese *Sezession* in 1898. His works were viewed with great interest in Vienna, Munich, Paris and Brussels. He also had a lot of influence on the progressive young artists of these cities.

Ill.pp. 62 top, 63, 64 bottom

STEINLEN, Théophile-Alexandre

Lausanne 1859 - 1923 Paris

The Franco-Swiss painter and graphic artist worked in Paris from 1882. With his sociocritical sketches and caricatures from the lives of the workers and middle classes he soon became famous. They were published in various newspapers and magazines and made him the critical chronicler of Montmartre even before Toulouse-Lautrec. He first discovered Art Nouveau through his contact with Toulouse-Lautrec and his characteristic style of drawing. However, in contrast to Toulouse-Lautrec's harshness, Steinlen preferred to use a pleasant, elegant line which was well accepted by the public. The importance of his work is in the graphic area.

Ill.pp. 54, 55

STRATHMANN, Carl

Düsseldorf 1866 - 1939 Munich

Strathmann came from an upper middle-class family which held worldly views. After studying in Düsseldorf and Weimar, Strathmann moved to Munich where he became one of the most typical

representatives of the Schwabing Bohème from the circle concerned with the magazines *Pan* and *Jugend*. He was a friend of Th. Th. Heine and a committed graphic artist for *Jugend*. However, he soon found recognition for his paintings as well. His contacts in Düsseldorf and Weimar gave him several opportunities to exhibit and there were also some purchases by official bodies such as a special exhibition of his Salambo series in Düsseldorf which was later also shown at the International Art Exhibition in Munich and in the large exhibition in Berlin. He belonged to the founders of the *Vereinigte Werkstätten für Kunst und Handwerk* (United Workshops for Arts and Crafts).

His inclination for applied art was also clearly visible in his painting and his strongest works are probably in the area of design for material, tiles, wallpaper and theatre curtains.

Ill.p. 75

STUCK, Franz von

Tettenweiss, Bavaria 1863 - 1928 Munich

The German painter, graphic artist and sculptor was a student at the Munich Academy from 1881-1884. After further studies under Lindenschmidt and influenced by Dietz, Böcklin and Lenbach he occupied himself with the works of the Pre-Raphaelites, especially with the Belgian Fernand Khnopff who brought him closer to Symbolism.

In 1892, he was one of the leading artists who made the break with the official academic art trade. Together with Fritz Uhde and Wilhelm Trübner he founded the Munich *Sezession* which strengthened its supraregional significance with the publication of the journal *Jugend* in 1896.

Franz von Stuck played an important part in the spreading of Art Nouveau and had an enormous influence on the following generation of painters, many of whom he taught. As a result of the extraordinary recognition of his work, he was raised to nobility in 1906 and colloquially called the "painter prince".

Ill.pp. 68, 69, 70, 71

TOOROP, Jan

Poeworedjo (Java) 1858 - 1928 The Hague

Toorop studied for one year at the polytechnic in Delft, one year at the Academy in Amsterdam and because of his great talent he eventually received a grant for the Academy in Brussels (1882-85). From 1886 he was a member of the artists' group *Les XX*. As a member of the *Libre Esthétique* he got to know artists such as Khnopff, Vogel and Ensor who followed symbolistic tendencies. Through Whistler, Matthijs Maris and Seurat, Toorop developed to the art of Post-Impressionism. In his drawing work there is a suggestion of Beardsley. In his use of line, Art Nouveau is comprehended to its limits, something which is most obvious in his graphic work. In his complete oeuvre, he is regarded as the main representative of Symbolism in Holland.

Ill.p. 34

TOULOUSE-LAUTREC, Henri de

Albi 1864 - 1901 Malromé Castle (Gironde)

He was a pupil of the Academy in Paris and lived in the artists' quarter of Montmartre. In spite of close contact to Impressionism, he was not overly influenced by it, but more by Manet, Renoir and especially Degas. He discovered the Parisian life in the area where he had taken lodgings and learned to characterize the realistic in an easy-going impressionistic style of painting. With his outstanding technique and his ironical spirit he became a great portrayer of the milieu in those days.

Many of the artistes from the cabaret scene before 1900 would have remained unknown had they not been immortalized in Toulouse-Lautrec's incomparable posters. The style of his sketchy portraits and posters had an influence on graphic art in the whole of Europe.

Ill.pp. 48, 49

VAN DE VELDE, Henry

Antwerp 1863 - 1957 Zurich

The Belgian architect, designer, painter and writer studied from 1881-83 at the Antwerp Academy and then at the Durant studio in Paris.

In 1888 he became a member of the Belgian artists' group *Les XX*. He was strongly impressed by Seurat who brought him closer to Neo-Impressionism. However, a decisive element in his life was his contact with William Morris and the English reform movement. He became completely involved with Morris's ideas and from then on dedicated himself to the concept of the complete work of art in the spirit of Art Nouveau. He built houses and furnished and decorated them, all to his designs.

He carried on the Folkwang ideas which were initiated by Karl Ernst Osthaus and built the Folkwang-Museum in Hagen to house these ideas. Art Nouveau would have been unthinkable without van de Velde's brilliant contribution.

Ill.p. 33

VOGELER, Heinrich,

Bremen 1872 - 1942 Kasachstan

Vogeler studied from 1890-93 at the Art Academy in Düsseldorf. In 1894 he moved to Worpswede and joined the group of painters there- who, in their pantheistic spirit, aimed at the ideal of a return to nature. During a journey to Italy in 1898 an encounter with Rainer Maria Rilke had a lasting effect on him. The influence of the Pre-Raphaelites on his work is unmistakable. His paintings in subdued, bright colours, often with symbolistic content, radiate a fabulous atmosphere. His drawings and etchings — he was an extraordinarily talented and sensitive graphic artist — from the period in Worpswede can be assigned to Art Nouveau.

His experiences of the Russian Revolution and the encounter with Tolstoy's work turned Vogeler to Communism. In 1913 he moved to Moscow.

Ill.Table IV

LIST OF ILLUSTRATIONS

HANS CHRISTIANSEN Table I
Girl with Teapot. 1893
Watercolour, 46 x 34 cm
Städtische Kunstsammlung, Darmstadt

CARL OTTO CZESCHKA Table II
Music. 1898
Coloured drawing
Galerie Michael Pabst, Munich

FRIEDRICH KÖNIG Table III
Kneeling Woman with Red Garment. 1905
Watercolour, 22.2 x 18.2 cm
Galerie Michael Pabst, Munich

HEINRICH VOGELER Table IV
Folk Song. Ca. 1900
Watercolour, 17.5 x 15.8 cm
Private collection

HENRY VAN DE VELDE 33
Making Hay. 1891/92
Oil on canvas, 75 x 95 cm
Musée Petit Palais, Geneva

JAN TOOROP 34
Old Oak-Tree in Surrey. 1890
Oil on canvas, 64 x 76 cm
Stedelijk Museum, Amsterdam

WALTER CRANE 35
Signs of Spring. 1894
Watercolour, 78.5 x 60 cm
Private collection

WALTER CRANE 36/37
The Horses of Neptune. 1892
Oil on canvas, 86 x 215 cm
Neue Pinakothek, Munich

EDWARD BURNE-JONES 38
Sponsa da Libano. 1891
Watercolour, 31.7 x 15.3 cm
Walker Art Gallery, Liverpool

FERNAND KHNOPFF 39 top
I Lock Myself in. 1891
Oil on canvas, 72 x 140 cm
Neue Pinakothek, Munich

FERNAND KHNOPFF 39 bottom
Caresses. 1896
Oil on canvas, 50.5 x 150 cm
Musées Royaux des Beaux-Arts de Belgique, Brussels

THEO VAN RYSSELBERGHE 40
Irma Sèthe. 1894
Oil on canvas, 197 x 114 cm
Musée Petit Palais, Geneva

PETER SEVERIN KRØYER 41 top
Summer Evening on the Beach with Anna Ancher and Maria Krøyer. 1893
Oil on canvas
Skagens Museum, Skagen

CARL LARSSON 41 bottom
Late Summer. 1908
Watercolour
Private collection

EDVARD MUNCH 42 top
Dance of Life. 1899-1900
Oil on canvas, 126 x 191 cm
Nasjonalgalleriet, Oslo

EDVARD MUNCH
Winter's Night. Ca. 1900
Oil on canvas, 80 x 100 cm
Kunsthaus, Zurich

EDVARD MUNCH
Madonna. 1894/95
Oil on canvas, 91 x 71 cm
Nasjonalgalleriet, Oslo

GEORGES LACOMBE
The Years of Life. 1892
Oil on canvas, 151 x 240 cm
Musée Petit Palais, Geneva

PAUL RANSON
Two Nudes. 1890
Charcoal drawing on tinted paper, 120 x 98 cm
Musée Petit Palais, Geneva

HENRI J.E. EVENEPOEL
Café d'Harcourt, Paris. 1897
Oil on canvas, 114 x 148 cm
Städelsches Kunstinstitut, Frankfurt

JEAN-LOUIS FORAIN
"Trottin de Paris". 1895
Ink, watercolour and gouache, 168 x 83 cm
Musée Petit Palais, Geneva

HENRI DE TOULOUSE-LAUTREC
Jane Avril Dancing. Ca. 1892
Thinned down oil paint on cardboard, 85.5 x 45 cm
Musée d'Orsay, Paris

HENRI DE TOULOUSE-LAUTREC
The Milliner. 1900
Oil on wood, 61 x 49.3 cm
Musée Toulouse-Lautrec, Albi

MAURICE DENIS 59
The Muses. 1893
Oil on canvas, 135 x 68 cm
Musée National d'Art moderne, Paris

MAURICE DENIS 60/61
The Holy Grove. Ca. 1900
Oil on canvas, 124 x 293.5 cm
Musée Petit Palais, Paris

GIOVANNI SEGANTINI 62 top
The Wicked Mothers. 1894
Oil on canvas, 120 x 225 cm
Kunsthistorisches Museum, Vienna

GIOVANNI SEGANTINI 62 bottom
The Love at the Source of Life. 1896
Oil on canvas, 69 x 100 cm
Galleria d'Arte Moderna, Milan

GIOVANNI SEGANTINI 63
The Angel of Life. 1894
Oil on canvas, 276 x 212 cm
Galleria d'Arte Moderna, Milan

FERDINAND HODLER 64 top
Night. 1890
Oil on canvas, 116 x 299 cm
Kunstmuseum, Berne

FERDINAND HODLER 64 bottom
Eurythmy. 1895
Oil on canvas, 167 x 245 cm
Kunstmuseum, Berne

CARLOS SCHWABE 65
The Angel of Death. 1909
Pencil, watercolour and gouache on paper, 75 x 55.5 cm
Musée d'Orsay, Paris

RICHARD RIEMERSCHMID 66
Cloud Ghosts I. 1897
Crayons on cardboard, 45 x 77 cm
Städtische Galerie im Lenbachhaus, Munich

RICHARD RIEMERSCHMID 67
In the Freedom of Nature. 1895
Oil on canvas, 87 x 63 cm
Städtische Galerie im Lenbachhaus, Munich

FRANZ VON STUCK 68/69
Dancers. Ca. 1896
Oil on wood, 52.5 x 87 cm
Collection Georg Schäfer, Euerbach

FRANZ VON STUCK 70
Spring. Ca. 1909
Oil on wood, 63 x 60.5 cm
Hessisches Landesmuseum, Darmstadt

FRANZ VON STUCK 71
Springtime Dance. 1909
Oil and tempera on wood, 115 x 110 cm
Hessisches Landesmuseum, Darmstadt

LEO PUTZ 72
Girl in a Glass. Ca. 1902
Oil on wood, 55.3 x 26 cm
Städtische Galerie im Lenbachhaus, Munich

HANS OLDE 73
Grand Duchess Caroline of Saxony-Weimar. Ca. 1903
Oil on canvas, 198 x 153 cm
Städtische Galerie im Lenbachhaus, Munich

THOMAS THEODOR HEINE 74
The Hammock. 1892
Oil on canvas, 58 x 76 cm
Neue Pinakothek, Munich

REGISTER

Photographic Acknowledgements:

Artothek J. Hinrichs, Peissenberg: p. 36/37, 39 top, 66, 72, 74, 75
Archiv für Kunst und Geschichte, Berlin: p. 35, 41 bottom
Foto Edelmann Frankfurt: p. 46
The Bridgeman Art Library, London: p. 41 top, 52, 53
Cholorphoto Hinz, Allschwil: p. 64 top, 64 bottom
Phototèque des Musées de la Ville de Paris: p. 60/61
Service photographique de la Réunion des Musées Nationaux, Paris: p. 48, 50, 59, 65, 76
Istituto Fotografico SCALA, Antella: p. 62 bottom, 63
Photographie Giraudon, Paris: p. 51
Archiv Worpsweder Verlag, Lilienthal: table IV
Galerie Welz, Salzburg: p. 79
Galerie Würthle, Vienna: p. 78
Tables II, III: from Michael Pabst, Wiener Grafik um 1900, Verlag Silke Schreiber, Munich 1984

If not stated differently, the photos were obtained from museums, galleries and collections or are from the Berghaus archive.